T0150884

LITTLE BOOK OF

Dior

Published in 2020 by Welbeck
An imprint of Welbeck Non-Fiction Limited, part of
Welbeck Publishing Group
Based in London and Sydney.
www.welbeckpublishing.com

A CIP catalogue for this book is available from the British Library.

ISBN 978-1-78739-377-6

Printed in China

24

LITTLE BOOK OF

Dior

KAREN HOMER

WELBECK

Contents

INTRODUCTION

"My dream? To make women happier and more beautiful."
— Christian Dior

In 1947 in Paris – a city still reeling from the Nazi occupation of Europe, where rationing and austerity continued to affect every area of life – an idealistic couturier by the name of Christian Dior had just opened his own fashion house. His first collection was eagerly anticipated, and as models sashayed through the elegant dove-grey rooms of his salon, there was a collective intake of breath. Gone were the square-shouldered, masculine jackets and neat, short skirts of wartime, replaced by perfectly tailored elegant jackets that moulded themselves to the curves of the models; waists were tinier than could be imagined and hips rounded exaggeratedly over skirts that swirled in yards of fabric. It was an audacious debut, immortalized in the words of Carmel Snow, editor-in-chief of *Harper's Bazaar*: "It's quite a revolution, dear Christian! Your dresses have such a new look!" Fashion history was made and the New Look was born.

Despite its creator's untimely death just a decade later, the haute couture house that Christian Dior founded has always stood for glamour, elegance and luxury. The tenets of design that Dior laid down in the beginning – an architectural level of skill in tailoring and craftsmanship, a focus on femininity and making a woman feel more beautiful in his clothes, a clever marriage between the historical influence of fashion

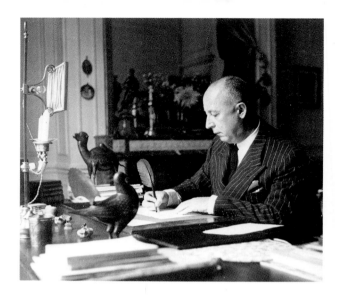

and meeting the needs of a modern woman – have endured
for more than 70 years. The New Look is still instantly
recognizable and is a touchstone for fashion historians and
designers alike.

The immensely talented head designers who succeeded
Dior, including Yves Saint Laurent, Marc Bohan,
Gianfranco Ferré, John Galliano, Raf Simons, and current
chief Maria Grazia Chiuri, have respected the designer's
intentions while still offering their individuality to the
label. Alongside a savvy business team, they have steered
the label through the changing world of fashion, from the
rise of ready-to-wear and accessories to the brand's global
expansion into fragrance and cosmetics. Today, Dior is
one of the most successful luxury brands in the world, and
its founder is far from forgotten. With the wildly popular
retrospective *Christian Dior: Designer of Dreams* shown first in
Paris in 2017, and then in London in 2019, the vision of the
designer continues to be shared with a new generation.

Early Life

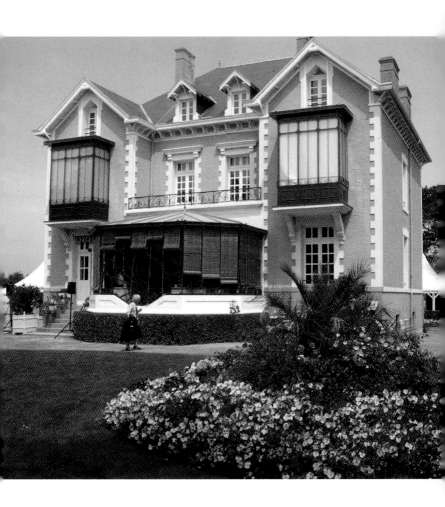

ABOVE Christian Dior's childhood home in Granville, Normandy, as it is today. His beloved flowers inspired a lifelong passion for floral designs and embellishments that endures at Dior to this day.

AN IDYLLIC
CHILDHOOD
HOME

Christian Dior was born on 21 January 1905 in Granville,
a smart seaside town on the coast of Normandy,
and was the second of five children.

H is family was wealthy thanks to a fertilizer and chemicals
business founded by his great-great grandfather in 1832.
In his autobiography, *Dior by Dior* (1957), Dior described
their Normandy clifftop home: "like all Anglo-Norman
buildings at the end of the last century … [it was] perfectly
hideous [but] … in a certain sense my whole way of life was
influenced by its architecture and environment". The house
was painted a "very soft pink, mixed with grey gravelling,
and these two shades have remained my favourite colours in
couture". In the linen room, housemaids and seamstresses
worked tirelessly; Dior recalls it was "the place I loved more
than any other … I lingered … absorbed in watching the
women around the oil lamp plying their needles".

As a child, Dior exhibited a passion for flowers and was
happy to spend hours alone among the plants and flowerbeds
or reading *Vilmorin-Andrieux* botanical catalogues. This
interest, inherited from his mother, heavily influenced
his work as a designer: he loved to sketch sitting in his

gardens, and used abundant floral patterns, embroidery and
embellishments on his gowns and dresses. His New Look
silhouette was designed to represent an inverted flower, and
the salons of Maison Dior were always full of grand floral
arrangements. The garden and floral theme runs through
the company to this day – all the designers to succeed
Christian Dior have used floral fabrics and embroidered
flowers or petals made from silk, as well as incorporating
fresh flowers into catwalk and haute couture shows.

Christian Dior was five years old when his family moved
to a grand apartment in Paris. The city was enjoying the
final years of the Belle Époque, a golden age before the
outbreak of World War I. The young Dior happily absorbed
the atmosphere of gaiety and creativity in a period when
the arts, theatre and music flourished. Once the war was
underway, life was more tense, but Dior wrote of keeping
up morale by singing and dancing. He was already showing
an interest in fashion when a magazine from Paris arrived,

RIGHT Dior spent hours as a child reading botanical catalogues, sparking a passion for floral print and design.

"announcing that the Parisiennes were wearing short skirts and 'flying boots' … laced up to the knees. Disapproval was unanimous and powerful. All the same, on that very day, each one hastened to order boots and short skirts from Paris by the evening post."

After the end of World War I, a teenage Dior immersed himself in contemporary arts, literature and music, attending private views and patronizing small, exclusive galleries. After finishing school, Dior suggested to his parents that he pursue his interest in architecture and study fine arts. However, they did not feel this would lead to a suitable career and instead enrolled him on a political science course with a view to launching him into a career as diplomat. Nevertheless, Dior pursued his passion for the arts, admiring the new surrealist painters, watching expressionist avant-garde films and spending nights at plays by Anton Chekhov. He was also seduced by the glamour of the Folies Bergère and other lively venues, quickly becoming a fan of performers like the Dolly Sisters and Josephine Baker.

It was soon obvious that a career as a diplomat would not suit the young Dior, so he persuaded his parents to allow him to study musical composition instead. He experimented with expanded tonality and was impressed by composers such as Henri Sauguet, although his parents despaired at the sounds coming out of their drawing room. The cultural life that Dior led during these formative years not only helped develop his personal tastes but also led him to make friends within a wide social circle that would stay with him for life. One of these friends, Jean Ozenne, worked in couture and had an early influence on Dior's future career.

For several years, Dior had managed to postpone his military service because he was still a student, but in 1927 he was finally made to sign up. Declaring himself an anarchist and a pacifist, he refused to join the officers' squad and instead became a second-class sapper in the Fifth Génie de Versailles, a regiment near Paris. Using this time to decide what he was going to do next, Dior proposed that he should

RIGHT Avant garde
performers like
Josephine Baker were
compelling to the
young designer and
Dior later created
outfits for Miss Baker
to wear on stage.

open an art gallery, despite his parents' reservations. His
father agreed to back Dior on the proviso that his name did
not appear on the gallery itself, as to have one's name over
a shop door would have been the pinnacle of social shame
to his traditional and well-to-do parents. Dior went into
partnership with his friend Jacques Bonjean and opened
a small gallery that traded in what would become some of
the most important painters of the century, including Pablo

Picasso, Henri Matisse, Salvador Dalí and Max Jacob. Dior later commented that if he had kept the stock of paintings, their value would have been incalculable. In 1928, Dior met Pierre Colle, who became a close friend and joined the staff of the gallery.

In 1930, just after the American economic crash sparked the worldwide Great Depression, Dior suffered a series of blows. First, his brother was diagnosed with an incurable nervous disease and his beloved mother, full of grief, faded away and died. Shortly after, at the beginning of 1931, the depression hit France and his father, who had invested heavily in real estate, saw his fortune vanish. With bailiffs arriving at the house to seize any assets they could, Dior moved the family's artworks to the gallery. But Jacques Bonjean's family had suffered a similar fate, and soon the gallery had to close. Dior, determined to keep going, partnered with Pierre Colle to open a new gallery, but artworks had devalued so dramatically that it was impossible to stay afloat, and this too was soon forced to close.

Dior was left virtually destitute. His family had returned to Normandy, unable to afford to live in Paris. Dior himself was forced to share attic rooms with friends. But looking back, he remembered the camaraderie and determination to find small pleasures during these hard times: "For a night, with the help of a few bottles, a piano, and a gramophone we would keep away the mice as we invented fantastic amusements ... [including] Charades in fancy dress".

Perhaps inevitably given his peripatetic lifestyle, Dior fell seriously ill and was forced to leave the city for healing mountain air. During the year he spent abroad, Dior began exploring his own creativity. He learned the art of tapestry, worked on his designs and even considering setting up a

workshop. But when he finally returned to Paris, Dior needed a steady job and applied to the fashion house of designer Lucien Lelong. In the interview, he found himself suggesting he would be more useful working on the couture side of the business than in the office. Although Dior wasn't given a job at the time, Lelong would later hire him as a designer.

Fortunately, Dior finally had a stroke of good luck – he was able to sell one of the few paintings he had left, *Plan de Paris* by Raoul Dufy, which he had bought cheaply. This gave him the funds to postpone the need to find a job immediately, as well as to help his family, who were still struggling. At the same time, Jean Ozenne, then a fashion designer before his acting career took off, suggested Dior train as a fashion illustrator. Dior had obvious flair and was soon selling sketches to fashion magazines and dedicating himself to creating dress and accessory designs. Over the next two years, Dior built a reputation for himself as a designer. He found himself a flat and, in 1938, was hired by Robert Piguet as an in-house designer, where Dior was credited with designing the *Cafe Anglais* dress in houndstooth with a trimming of lace that was much admired that season. It was here that the designer was first introduced to Carmel Snow, the *Harper's Bazaar* editor who would later coin the term "New Look". But before that exciting part of Dior's life could begin, his career was interrupted by the outbreak of World War II, and in 1939, the 34-year-old designer was called up again for military service.

The

War Years

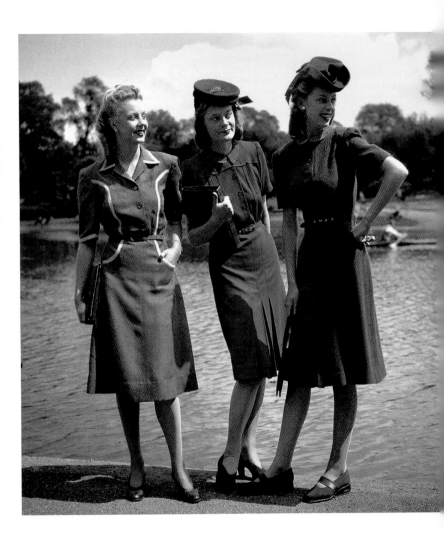

ABOVE Fabric rationing during World War II led to British designer Norman Hartnell releasing patterns for streamlined "utility dresses", which used a bare minimum of cloth. Dior's extravagantly full New Look dresses were a shocking contrast to the austerity of the war years.

FIGHTING FOR COUTURE

Christian Dior spent only a year doing military service and was lucky enough to avoid active combat.

Instead, he was stationed in Mehun-sur-Yèvre in central France among down-to-earth peasants, wearing wooden clog-like "sabots" on his feet – far from the rarefied world of couture. During this time, Dior discovered a love of working the land and after finishing his military service in 1940, he rejoined his impoverished family in the South of France. There, he helped his father and sister Catherine in growing vegetables, which brought in good money at the market during a time of food rationing. Dior then received some incredible news: several pictures that he had sent to America before the war had been sold. He received a windfall of 1,000 dollars, quite probably some of the last foreign currency to be allowed into France.

Even outside the cultural centre of Paris, Dior managed to find himself among an artistic crowd. Despite the deprivations of war, he socialized with the many Parisians who had retreated to Cannes, where putting on theatrical performances was a regular pastime. Dior also continued to send his fashion sketches to the newspaper *Le Figaro*, where

they were featured in the women's pages. By the end of 1941 the couture houses in Paris had reopened their workshops and Dior decided to return to his design job with Robert Piguet. Unfortunately, Piguet had tired of waiting for Dior to come back and had replaced him. Dior was instead taken on by Lucien Lelong, who ran a larger couture house with an excellent tradition of fine workmanship, which turned out to be a far better training ground.

Dior worked alongside Pierre Balmain at the House of Lelong, one of the few couture houses that remained in France during the German occupation. Other designers, including Mainbocher and Schiaparelli, left for America. Some, like Madeleine Vionnet, closed, never to reopen. Lelong, then the president of the Chambre Syndicale de la Haute Couture, trod a fine line negotiating with the Nazis,

BELOW Christian Dior worked for fashion designer Lucien Lelong 1941–1946, learning a huge amount about haute couture and contributing designs that showed an early version of his New Look.

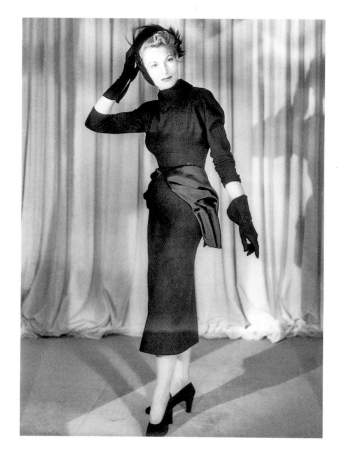

RIGHT Christian Dior
continued to hone
his skills as a fashion
designer under the
tutelage of Lucien
Lelong.

who had demanded that the Paris couture houses be moved
to Berlin. Germany's plan was to move the couturiers
to Hitler's Third Reich, where they would use German
dressmakers and essentially become German designers. In
1941, the Chambre Syndicale was inspected and the archives
requisitioned. However, the plan to appropriate the tradition
of French couture and make the industry German was
impractical. As Lelong explained to the Nazis, the fashion
houses relied on thousands of artisans skilled in techniques

such as embroidery, and it would be impossible to teach a new generation of German workers skills that had been passed down through generations. The Nazis reluctantly acquiesced, allowing the houses to remain open and the couturiers to continue working in Paris, but it was a time fraught with the constant worry that the maisons would be forced to close.

Lelong did manage to remain open during the war, often designing dresses for Nazi officers' wives. After France's liberation, it was suggested that Lelong had been a collaborator. However, at his trial the judge ruled that he had cooperated with the Germans as little as possible – and only in order to save French jobs and the cultural legacy of French couture. In 1945, as Paris fashion was starting to recover, Lelong sent a pared-down collection abroad, including some dresses with nipped-in waists and longer-length skirts. It was a taste of what was to come, and it was almost certainly designed by Christian Dior and Pierre Balmain. Two years later, Lelong was in the audience when Dior showed his legendary New Look collection, which Lelong greatly admired. His protégés had outgrown him, and while Lelong emulated Dior by showing a collection with the New Look silhouette the following year, he closed his couture house in 1948, citing health problems. Dior always spoke fondly of his mentor, acknowledging the skills he had imparted and the freedom he had given Dior to find his way as a designer.

Life in occupied France was a difficult time, and no one fought back harder than Christian Dior's beloved younger sister, Catherine. Despite a 12-year age gap, the siblings were extremely close, and Dior had found his sister a job in Paris, where they lived together before the war. It was there that she fell in love with married shopkeeper Hervé

des Charbonneries and, scandalously, started living with him. When he revealed to her that he was a member of the French Resistance, Catherine immediately joined the rebel organization as a spy. But, on 6 July 1944, Catherine was captured and arrested by the Gestapo and detained at Drancy, an internment camp in the suburbs of the city.

Catherine was tortured for information, and when she refused to betray the Resistance, she was shipped by train to Ravensbrück, Germany's largest concentration camp for women. The Dior family never gave up hope that she would return to them, and on 30 April 1945, the Soviet Army liberated the camp at Ravensbrück. Catherine returned emaciated and fragile, part of her irreparably damaged. She received several awards, including the Légion d'Honneur, the highest commendation for military and civil merits. Her strength and patriotism were an inspiration to her brother Christian, and she was his greatest supporter when he launched his New Look.

Despite her role as a muse to her brother – embodying all the strength, humility, and grace he valued so highly in women – Catherine shunned the limelight. She stayed with her lover permanently, helping to raise his children, and spent her life devoted to growing flowers, many of which were used for Dior's fragrances. Appropriately, his first-ever scent, *Miss Dior*, was named for her. After Dior's death in 1957, Catherine got permission for the many flowers sent in tribute from around the world to be laid at the Arc de Triomphe as a mark of respect for his great contribution to French couture. Catherine inherited much of her brother's fabric, furniture and paintings. Upon her death in 2008 at age 91, these belongings were returned to the newly restored Château de La Colle Noire, where Christian Dior once lived.

The
New Look

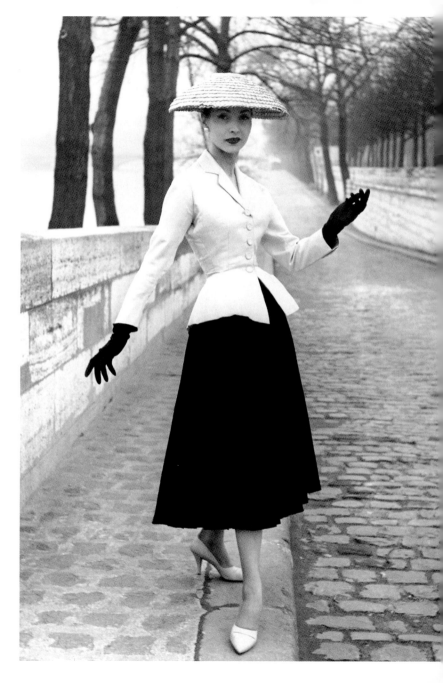

"IT'S QUITE
A REVOLUTION,
DEAR CHRISTIAN!"

In 1946, Christian Dior was approached by the extremely
wealthy textile magnate Marcel Boussac, who was impressed
by Dior's work and wanted a designer to resurrect an old
fashion house named Philippe et Gaston.

The offer was tempting. However, Dior refused to work
under another's name, insisting that the new house
be eponymous. Boussac agreed to back him, and on 16
December 1946, the house of Christian Dior opened its doors
at 30 Avenue Montaigne. The designer's eagerly anticipated
first collection – the last haute couture show of the Spring/
Summer season – was unveiled on 12 February 1947 to a
room packed with the upper echelons of Parisian society,
alongside the most stylish of the fashion crowd. As the models
began to parade the 90 debut looks around the elegant grey-
hued salon, the atmosphere was "electric", American *Vogue*
editor Bettina Ballard later wrote.

OPPOSITE This iconic image of the New Look has a woman
posing elegantly, wearing Dior's peplum "Bar" jacket with its
sloped shoulders and tiny waist that flares over the hips to meet
a full black skirt – topped with a woven hat.

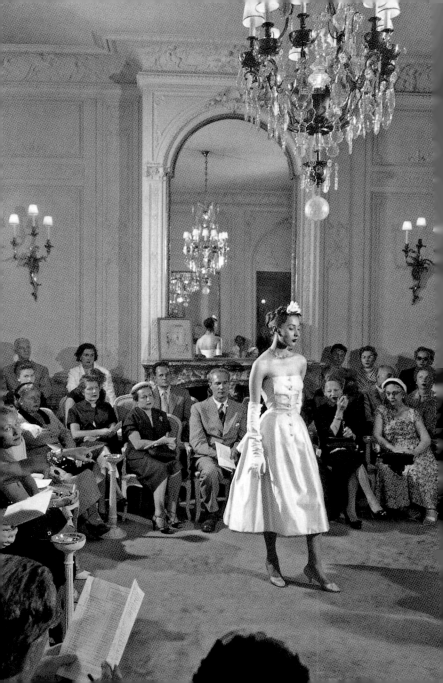

Journalists around the world were suitably impressed with Dior's debut collection, which quickly graced the cover of American *Vogue*, but it was Carmel Snow, the editor-in-chief of *Harper's Bazaar,* whose words immortalized this daring style: "It's quite a revolution, dear Christian! Your dresses have such a new look!" And so the term "New Look" was coined – and with it, a whole new way of dressing was born.

Dior's tailoring has often been described as having an architectural quality, and his love of beautifully structured garments in the finest cloth is often recognized as his trademark. The expertise of his dressmakers is readily apparent from the meticulous attention paid to the clothes. However, it is important to understand just how revolutionary the New Look was. World War II had ended less than two years previously, and France was still recovering from German occupation. Similarly, in Britain – where Dior was popular, particularly among the upper classes – clothes rationing lasted until 1949. When the New Look first burst onto the scene, it was the exact opposite of the fashion that had come before it, in which shoulders had been squared off, hats had been adorned with flowers and fruit, and shoes had heavy platforms. In contrast, Dior's collection was breathtaking in its pared-back silhouette. The neatly rounded shoulders, curved waist and flared, elegant skirts were fluid yet structured, exquisitely tailored yet flattering and easy to wear. Footwear and millinery were integral to Dior's overall style, and he accessorized his looks with neat heels and sharply drawn hats. The designs that Dior created, although beautiful, were viewed by some as shockingly extravagant. But there were plenty of women for whom the end of wartime austerity could not come soon enough, and buying a New Look suit was one way to signal the start of a new era in fashion.

OPPOSITE Dior's collections, as seen here in 1950, were shown in the elegant, grey-painted salon of his atelier at 30 Avenue Montaigne and always attracted a full house.

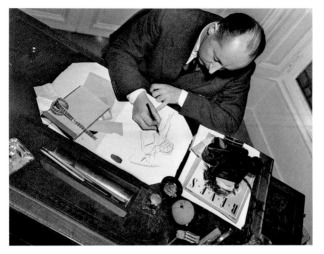

LEFT Christian Dior was a talented artist who created beautifu sketches of his revolutionary 1947 New Look dresses.

LEFT A haute couture collection typically showed over 200 designs carefully selected by Dior himself, to be made up by his team of talented atelier artisans.

Christian Dior's first collection presented two distinct silhouettes: the "Corolle", which Dior described in the press notes as "dance-like, very full-skirted, moulded bust and slim waist", and the "En Huit" or "8" line, characterized by the designer as "clean and rounded, the chest is underlined, hollowed-out waist, accented hips". What is obvious in these descriptions is Dior's love of the female form. His clothes were designed to accentuate the curves that were there, and give the illusion of an hourglass figure to those who weren't naturally built that way.

Take, for example, the iconic and monochromatic "Bar" suit that immediately springs to mind when one thinks of the New Look: it has a beautifully tailored ivory silk jacket with a tiny waist flaring over rounded hips and an almost gratuitously full pleated skirt, made from four metres of black wool, that falls to mid-calf. Other suits and dresses from the collection were tailored in the same way. This style, paired with Dior's use of a subdued colour palette, including shades he described as "navy, grey, griege and black", rendered the collection at once modern and nostalgic. The accentuated curves revealed the influence of both Edwardian-era corsetry and the exaggerated, wide skirts of the nineteenth century, yet the look was softened by modern colours and shape – and instantly recognizable as a fashion classic.

Dior's second collection, for Autumn/Winter 1947, was hotly anticipated by the fashion world; would the designer be able to deliver another collection as perfectly curated and innovative as his debut performance? The answer was yes, and the New Look of Autumn/Winter 1947 was pushed to even greater extremes, as American *Vogue* confirmed: "His second collection proves that he is not just occasionally good." The new silhouette continued to exaggerate the

female form, drawing in waists even more tightly, rounding and softening the shoulder to contrast more drastically to the sharp, wide shoulders that had been so popular just a year previously and, if possible, skirts were even fuller. *Vogue* reported "immensely wide, immensely long skirts" and Dior, in his autobiography, recalled using "a fantastic yardage of material [that] … this time went right down to the ankles".

Dior again used a flower analogy as he described how he inserted pleated "petal panels" into long, flared skirts. When an outfit presented a straighter, tubular skirt, the designer paired it with a jacket that had a padded peplum jacket, so the look still gave the illusion of exaggeratedly round hips and focused the eye on the woman's curves. For this cool-weather collection, Dior chose sumptuous, heavy fabrics

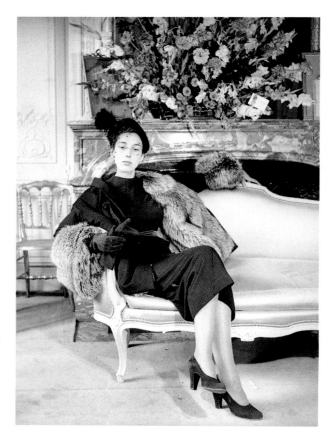

OPPOSITE In 1947, many Parisiennes were outraged by the amount of fabric being used in Dior's New Look dresses after wartime fabric rationing, and in protest tried to rip the dresses from the models.

RIGHT This model reclining in Dior's salon – full of elegant furniture and fresh flowers – and wearing a New Look mid-calf dress, offset with a fur-trimmed coat, veiled hat and gloves, epitomizes Dior glamour.

including velvet and brocade, and yet the models moved fluidly in their clothes. Dior spoke of an emotional lightness in this collection too, revelling as it did in liberation from war. He called this era a second "golden age", and believed "when hearts were light, mere fabrics could not weigh the body down."

Always a designer to consider the finished look of his outfit, Dior increasingly placed more importance on accessories. His second New Look collection introduced his signature side-hat, worn jauntily on one side of the head, an elegant twist of hair on the other. Within a few years, it

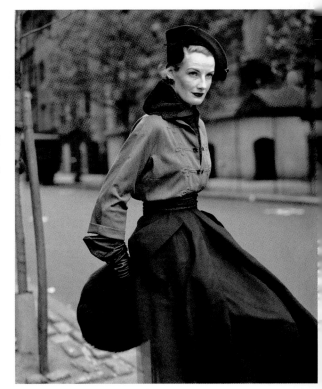

RIGHT This stunning hussar-style velvet and wool couture suit shows how Dior structured his outfits, juxtaposing a tight waist with full skirt and sleeves. The green accents in the hat, scarf and belt and the textural contrast of black leather gloves and fox-fur muff pull the look together.

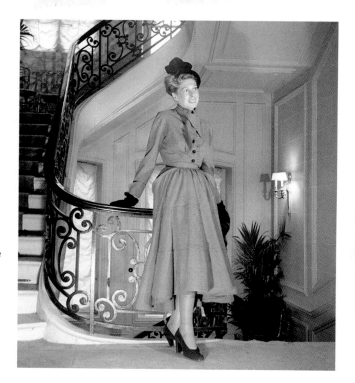

had become essential to the 1950s look. Jewellery, too, was crucial: the designer complemented his evening dresses with brilliantly sparkling statement necklaces.

Over the next few seasons, in the final years of the 1940s, Dior remained true to his groundbreaking silhouette, but there were subtle tweaks that made each new collection as well received as the last. For example, take his 1948 "Zig Zag" and "Envol" lines, the first described by the designer as giving the wearer "the animated look of a drawing"; the second line, translated as "Fly Away", distributed the fullness of the skirt unequally, a difficult design to pull off but one that allowed an increased sense of movement through the exaggerated rise and fall of the skirt.

The focus of Dior's new collections gradually moved from the bosom to the skirt, which became stiffer with the use of backing fabric for an even more structured finish. Even in the daywear outfits, Dior's usual impeccably tailored suits included a "stiffened wing protruding down the back". The "flightiness" that Dior sought with the "Envol" collection was confirmed in his winter "Winged" line, in which movement and volume were achieved with a single, deep inverted pleat in the back and front of dresses and coats. The "wings" were more literal, too, with details including high, pointed collars and exaggerated, pointed cuffs. This was also the season Dior started playing with asymmetric necklines on his evening gowns, to great effect.

RIGHT It is hard to believe now how scandalous Dior's longer-length skirts, with their greater fabric requirements, were in the late 1940s. Skirt lengths remained a defining factor in fashions for decades to come.

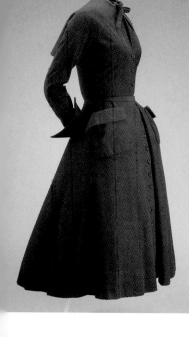

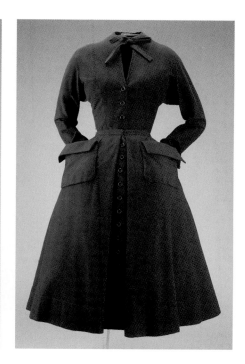

ABOVE This black Dior New Look wool melton day dress from 1948 has gently sloped shoulders – in contrast to the square, masculine shoulders of early 1940s fashion – a tiny waist and a full, long skirt. Dior also included details like large pockets, flared cuffs and neck bows.

One of Dior's great skills was to create optical illusions with his masterful cutting, most obvious in the way his outfits give the wearer an exaggerated female form. But he also used other techniques to trick the eye. In 1949, Dior even created a "Trompe L'oeil" line (literally translated as "deceive the eye") that used floating panels, which would swing to give the illusion of fullness, and carefully placed pleats in jackets and dresses. His judicious determinations of where to allow the fabric to fold added fluidity and volume despite the Dior silhouette essentially remaining clean and smooth.

This emphasis on the way Dior's garments were cut and the individual grain of his wide choice of luxurious

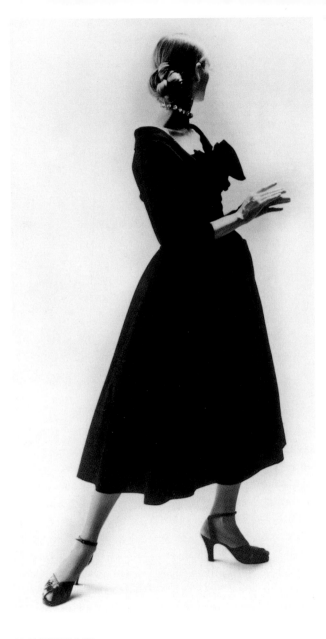

LEFT This stylized photograph by Cecil Beaton, of a woman wearing a 1947 New Look black wool dress, sums up the romantic mood of the collection perfectly.

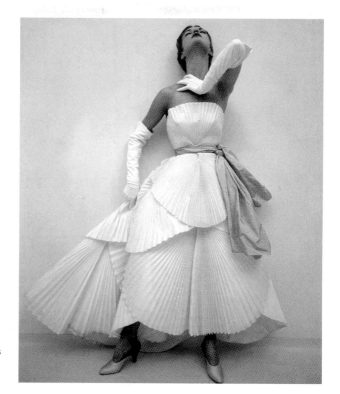

fabrics – including velvet, wool, silk, satin and grosgrain – continued to be of utmost importance to the designer. In his autobiography, he wrote of his final collection of the decade – the "Milieu du Siècle" ("Mid-Century") collection – that "it was founded on a system of cutting based on the internal geometry of the material". By playing with an intersection of straight- and bias-cut panels, which he likened to the crossing of scissors or fanning of windmills, he created a collection that pushed his design skills to dizzying new heights. And so the House of Dior entered the 1950s with a firmly established reputation as one of the most important names in haute couture.

The
House of Dior

EXPANSION INTO AMERICA & GREAT BRITAIN

At the beginning of the 1950s, Christian Dior had been head of his own haute couture house for just three years and had created fashion history with his daring New Look.

His clients included the cream of international society, royalty, and stars of the silver screen – expansion was a natural step for the designer. His first move was to strike licensing deals so that customers could buy the whole Dior "look" and in 1948, he licensed the manufacture of hosiery under his name, soon followed by arrangements for bags, shoes and jewellery. In the same year, he moved into the American market, opening a luxurious ready-to-wear store on New York's Fifth Avenue, as well as selling patterns for Dior garments to big department stores such as Bergdorf Goodman and Marshall Fields in Chicago. Dior would send the pattern, measurements and fabric, and seamstresses

OPPOSITE Christian Dior enjoyed the old-fashioned luxury of the *Queen Mary* ocean liner when he travelled to America after opening a luxurious store on New York's Fifth Avenue in 1948.

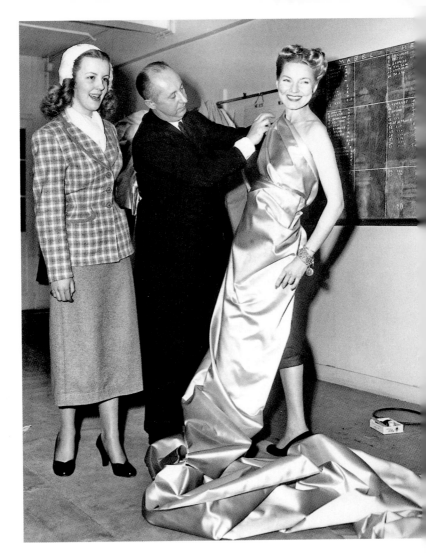

ABOVE In 1952, Dior went into business in Great Britain, producing new designs tailored to the tastes of English women. Here, he shows a seamstress how to drape an evening gown.

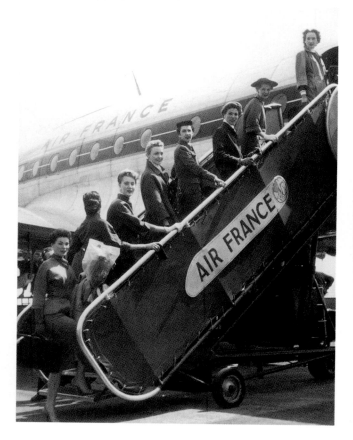

would copy the dress, which would then be sold, often in an
elegant salon within the store. Though the pieces were not
always as beautifully finished as the haute couture originals,
owning a little bit of Christian Dior at a fraction of the price
of couture was a dream come true for the American middle
classes.

In London, the demand for Christian Dior reached a
fever pitch when journalists covered his debut showing at
the Savoy hotel in 1950, especially when it became known

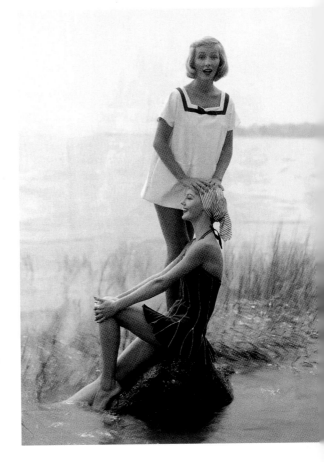

RIGHT American *Vogue* shows a blue ribbed Dior bathing suit in 1954. Specialized clothing was produced by manufacturers to whom Dior licensed his name and was incredibly popular.

that the glamorous Princess Margaret was a fan. However, other than a few licensed manufacturers who bought the rights to make copies from the toiles produced by the Dior ateliers, very few Dior garments could be bought in Britain. So, in 1952, Dior went into partnership with two clothes manufacturers, Coleman Jeffreys and Marcel Fenez, and Laura Ward, Countess of Dudley, to open C.D. Models (London) Ltd.

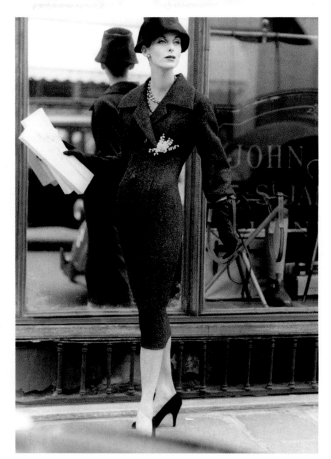

The Countess of Dudley was a remarkably well-connected woman with an innate elegance and sense of style, which made her the perfect ambassador for Dior's clothes in Britain. As well as being in charge of all press and marketing, she held the important job of selecting which designs would be reproduced at the London ateliers in Maddox Street. This was a responsibility that required a careful balancing of the British woman's sensibilities with Ward's desire to

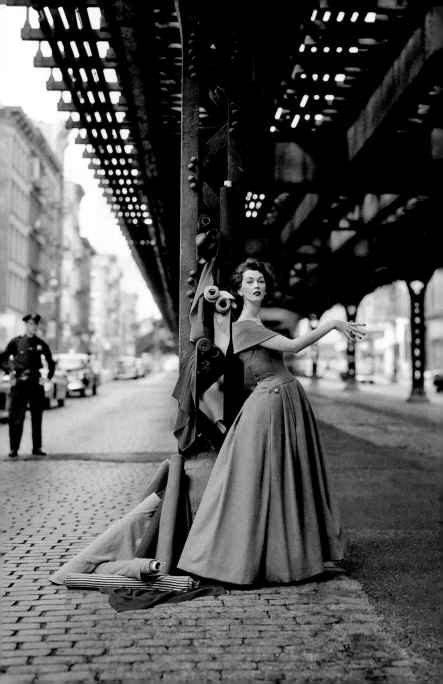

add a little French *joie de vivre* to her wardrobe. Needless to say, some designs had to be modified in line with what the upper-class Englishwoman found acceptable. By the end of 1954, Dior himself had become more personally involved in Christian Dior London (as it was now known), designing garments specifically for the British market. As an ardent Anglophile, he strongly encouraged the use of British fabrics. Similarly, when entering into licensing agreements for accessories or specialist clothing, Dior almost always chose British companies with a longstanding tradition of fine craftsmanship, like Dents gloves and Lyle & Scott knitwear.

Dior's popularity in Britain continued to grow, through fashion shows and press coverage. The designer, aware of his public persona, was happy to be interviewed about his design process and gave tips on how to dress more elegantly. A wide number of stores now stocked his clothes and accessories with some, like Harrods in London, holding in-store shows that emulated Paris haute couture when a new collection was released; Harrods even had its own "Dior Room" where customers could view all the latest designs and accessories. The love affair with Dior and his elegant clothes, so suited to the aristocratic classes, continued, and news of his sudden death in 1957 was received with great sadness.

Nevertheless, in November 1959, the House of Dior once again staged a show at Blenheim Palace in aid of the British Red Cross, with Princess Margaret as the guest of honour. This time, the designer-in-chief was the young Yves Saint Laurent, and the Dior label continued to show a separate London collection under a succession of talented designers until 1976.

OPPOSITE Dior enjoyed fantastic editorial coverage from American fashion magazines, including this 1956 shot of famous model Dovima posing in a Dior gown, surrounded by bolts of fabric, under the elevated railway in New York.

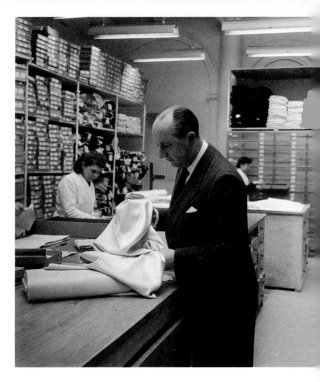

A NEW SILHOUETTE

In 1951, Christian Dior started to move away from his New Look silhouette with the launch of what he called the "Natural" line. Gone were the exaggeratedly padded hips and wide, stiffened skits, to be replaced instead by a focus on the oval. "Oval of the face, oval of the bust, oval of the hips: these three superimposed ovals ... follow the *natural* curves of the female body," he explained. The biggest departure was that skirts and suits for daywear now tapered gently towards the hem in a slim column and waists were no longer cinched tightly but tailored into a more natural shape. Jackets had lost the stiff corseting and Edwardian-style peplum to hang more loosely as far as the hip. Feminine curves were

still gently accentuated but the overall effect was far less extreme and, for many women, infinitely more wearable. The only dresses where Dior continued to let himself exhibit theatrics were in his evening wear collection, where his love of embellishment, glorious fabrics and grand flourishes was indulged.

The "Natural" line collection was succeeded by the "Long" line, the favourite of all Dior's collections, which

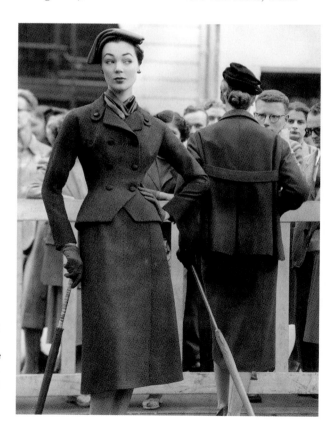

RIGHT In 1951, Dior introduced his "Natural" line collection. Corseted waists and extravagantly padded hips were replaced with designs that gave a more natural shape, using a cutaway short jacket and longer-length skirt.

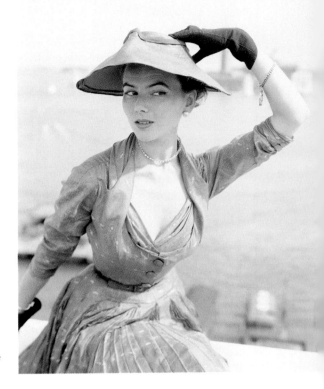

RIGHT This 1951 dress, with its low décolletage and belted waist, shows that even within his more natural silhouette, Dior still accentuated feminine curves in his designs.

boasted an even lengthier silhouette: skirts dropped to below the calf and his iconic peplum jacket was shortened so that the eye was drawn down a great length of skirt, emphasizing the slenderness of the woman's figure. The designer explained that his previous tricks to deceive the eye to create an artificial figure of womanhood were "out of date. Fashion is all about what is natural and sincere".

Dior continued to focus on a more natural celebration of womanly curves, playing with skirt lengths, presenting a jacket line unbroken at the waist and generally sculpting his designs to make women appear slimmer and more elongated

than ever before. His always demure colour palette now veered more towards black than the lighter tones he had favoured previously. Once again, only in his evening wear did he give free rein to his expressionism, creating richly embroidered gowns accessorized by wonderful statement jewellery.

Dior's love of flowers was well known, and he labelled his Spring/Summer 1953 collection the "Tulip" line, following it a year later with the "Lily of the Valley" line, after his

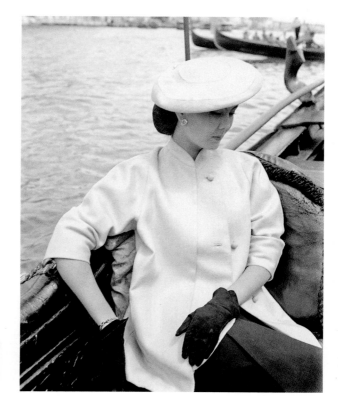

RIGHT This "paletot" was loose and full under the arms and fell to the hip, heralding a new silhouette. The design was described by *Vogue* as "a box coat with Chinese ancestry".

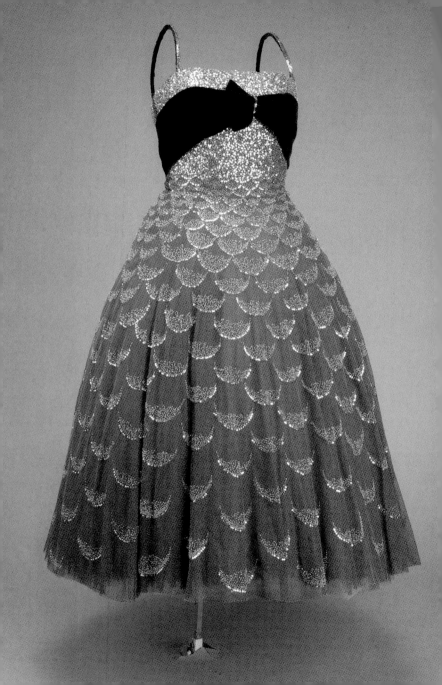

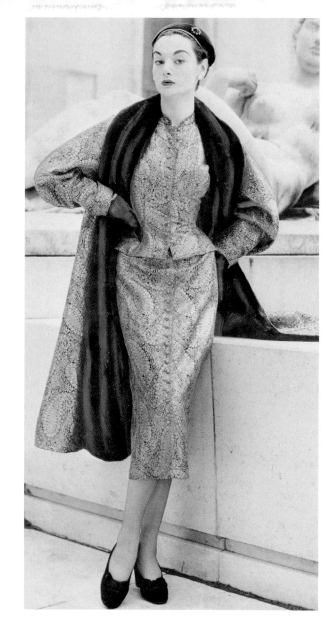

OPPOSITE This 1951 tulle ball dress, with glass beads and sequins and a large velvet bow detail across the bust, illustrates Dior's love of embellishment.

RIGHT Dior had a love of exotic, decadent fabrics, as shown in this outfit of a black-and-gold Persian-style lamé cocktail dress worn under a matching coat lined with black seal fur.

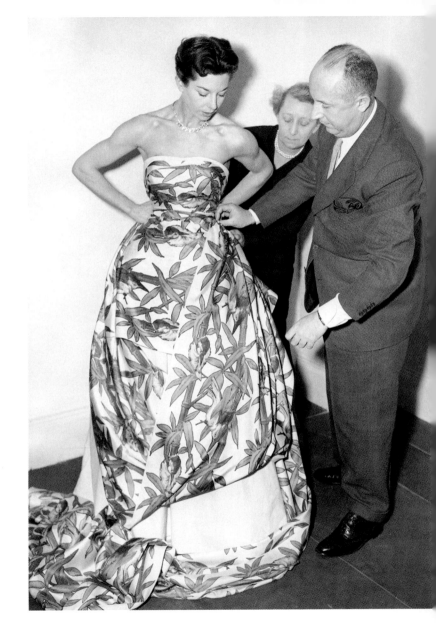

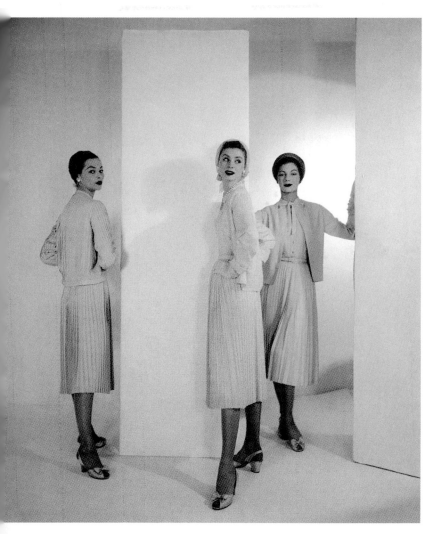

OPPOSITE Dior's childhood obsession with flowers and the garden led to a long-lasting love of floral fabrics and embellishments. This bold printed leaf and bird design is draped by the designer in an approximation of the gown it will become.

ABOVE These three-piece outfits made up of blouse, wool-crepe sweater and pleated skirt with kid gloves and brimless straw bonnets to match are a perfect example of Dior's 1952 "Long" line, with its lengthened and softened silhouette.

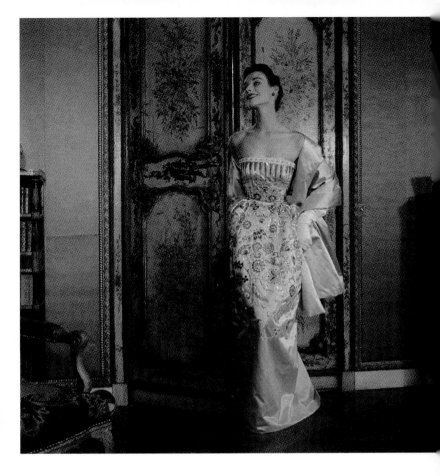

ABOVE This stunning ice-blue beaded satin ball gown, shown in *Vogue* in 1952, is classic Dior: tiny waist, curved hips and intricately beaded floral pattern, joined by a matching stole and gloves.

lucky flower. Vivid blues, pinks and purples brought to mind a carpet of mountain flowers and the prints and embroidery he used in the collection all had a floral theme inspired by gardens and orchards.

Throughout his final years, Dior created clothes that would become iconic designs. His mid-fifties collections of the "H", "A", and "Y" lines interpreted the female form in the shapes of these letters, with "A line" becoming common

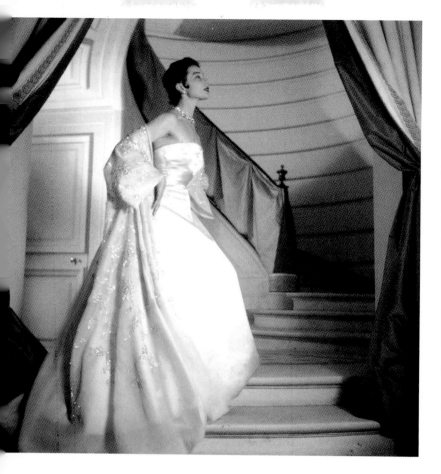

parlance in fashion. As the decade moved on, the brand's silhouettes became rounder and softer, impeccably structured as always yet somehow freer. Dior's final collection was Autumn/Winter 1957/58, in which he revealed his two extremes as a designer more than ever before: elegant day dresses and suits were shorter than in previous years and far less fitted; in contrast, his evening wear was extremely structured, with corseted torsos and billowing skirts. As

RIGHT During the 10 years that Dior headed his own couture house, he was incredibly involved in every aspect of designing and making the seasonal collections, inspecting garments at every stage of production.

American *Vogue* editor Jessica Daves wrote: "throughout, there is the unflagging professional perfection that explains … the continuing Dior eminence". No one could have foreseen that this would be the immensely talented designer' final collection, his career cut cruelly short by his sudden death from a heart attack while on holiday in Italy on 24 October 1957.

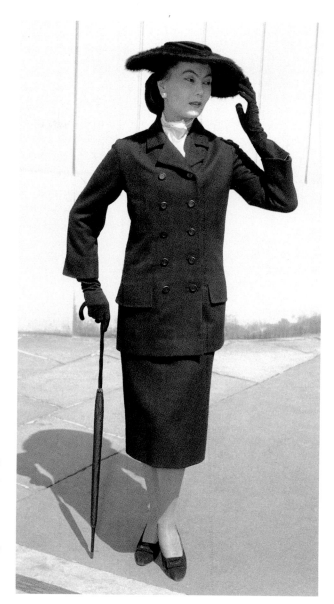

RIGHT This black
suit is from Dior's
"H" line, shown in
Autumn/Winter
1954/55, which he
described as focusing
in a "lengthening and
shrinking of the bust".
The waist is skimmed
rather than tightly
drawn in and the
jacket falls straight
from sloped shoulders
to the hips giving
an overall longer,
slimmer shape.

HISTORICAL INFLUENCES

The influence of historical fashion on Dior's – and subsequent designers' – collections is hugely important, and his final evening wear collection drew particular inspiration from famous eighteenth-century beauties, including Marie Antoinette and Madame de Pompadour. A preoccupation with this period is obvious from his New Look, with its exaggerated, padded hips and waists tightly corseted in. The fabrics Dior favoured were deeply evocative of the eighteenth century and sumptuous silks and velvets with intricate embroidery became a mainstay of his evening wear collections. The Belle Époque, so reminiscent of Dior's mother, also held sway over the designer, with its fluid lines and the way women were romanticized, something Dior continued to do throughout his career. The designers who succeeded Christian Dior also felt this historical influence deeply, and it surfaced in both traditional and innovative

BELOW RIGHT For Spring/Summer 1955, the "A" line silhouette is modelled at Dior's Paris showroom in front of fashion press, including Carmel Snow of *Harper's Bazaar*, who first coined the term "New Look", and Alexander Liberman of American *Vogue*.

OPPOSITE Dior's "A" line silhouette has became a fashion classic. Similar to the "H" line, the cross of the "A" plays on the waist and the skirt is more flared and often pleated. Narrow shoulders complete the shape.

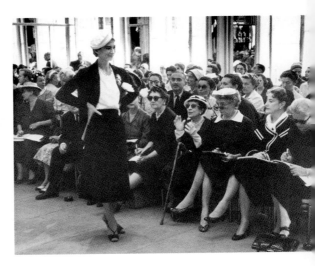

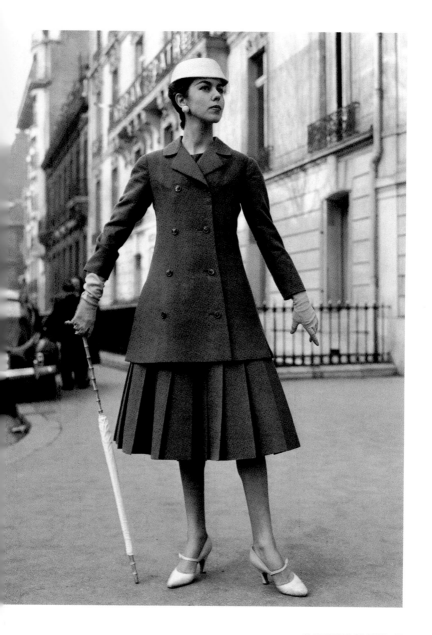

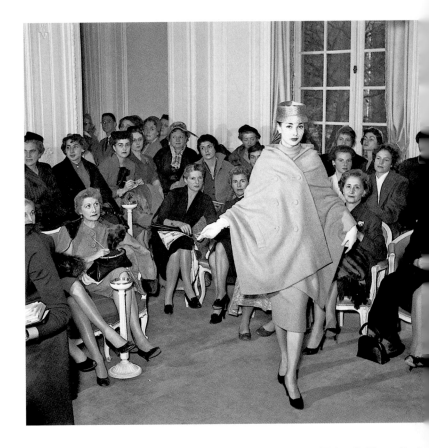

ways in the haute couture collections of John Galliano, Raf Simons and Maria Grazia Chiuri in particular.

To this day, Dior remains a design house with a strong grounding in what has come before. The designers who came after Christian Dior have not only honoured his nostalgia for the styles of previous centuries but also continued to create designs that reinterpret and acknowledge the importance of his own contribution to fashion history: the New Look.

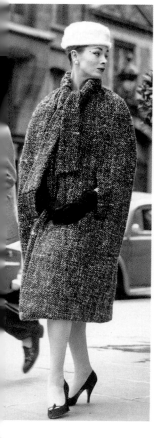

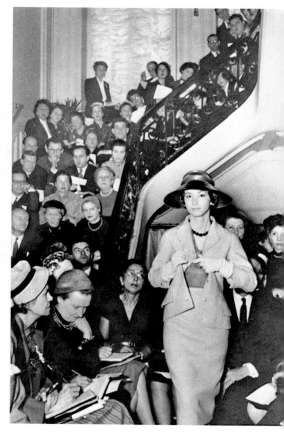

ABOVE This 1956 tweed coat and sack dress ensemble showed Dior had moved towards a more relaxed silhouette. While starkly different from his original sharply drawn New Look, these outfits were nevertheless extremely elegant and always perfectly accessorized.

ABOVE In the year before his untimely death, Dior had become so popular that his salon was tightly packed each time a new haute couture collection was shown.

OPPOSITE Dior's final collection based around the shape of a letter was the "Y line" shown in Autumn/Winter 1955–56. It showed a higher bust and new way of setting armholes combined with loose-fitting coats and jackets and long, slim skirts.

Hollywood
& Socialites

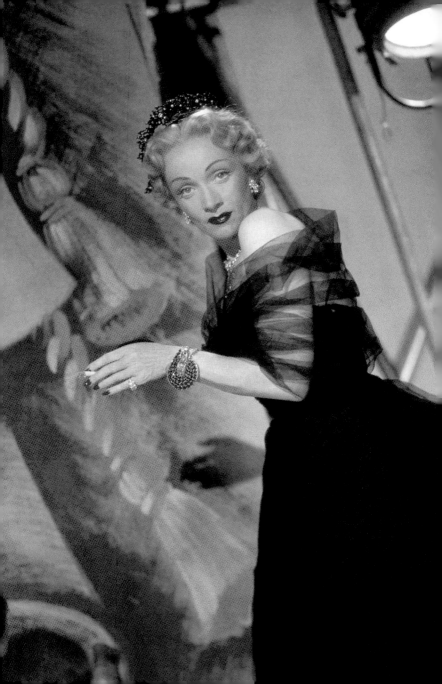

DIOR
AND
HOLLYWOOD

Christian Dior's reputation as the designer of the
moment spread quickly.

Although his profile was high, Christian Dior was not only
a talented designer but also a savvy businessman, and he
soon realized the necessity of bringing his designs to a wider
audience outside the rarefied atmosphere of haute couture
Paris, wider even than that which he had reached already
with licensing deals.

Of course, the designer needed his fabulous haute couture
dresses to inspire ordinary women to lust after his ready-to-
wear outfits, and few popularized the designer more than
the Hollywood sirens of the silver screen. Many leading
ladies already revered Christian Dior for his glamorous and
feminine designs, so it was inevitable that he would go on to
create dresses for their films. One such muse was Marlene
Dietrich, with whom Dior already had a close friendship.
When offered the role in Alfred Hitchcock's 1950 film *Stage*

OPPOSITE Dior designed the dresses for Marlene
Dietrich in the 1950 film *Stage Fright* after the actress
told director Alfred Hitchcock, "No Dior, No Dietrich!"

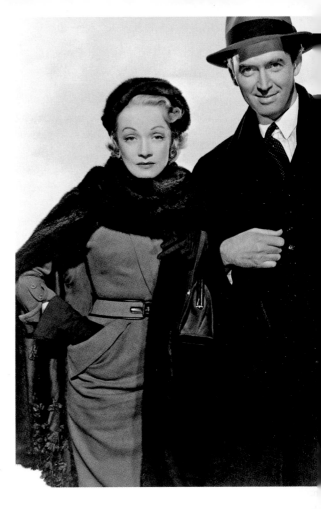

RIGHT German actress Marlene Dietrich wearing a Dior outfit in the 1951 film *No Highway in the Sky*.

Fright, the actress allegedly told the director: "No Dior, no Dietrich!" Dior went on to create all the dresses she wore in that film and future productions, including *No Highway in the Sky* in 1951. Other stars who were fans of the designer included Ava Gardner, for whom he designed all costumes for the 1957 film *The Little Hut*, and Olivia de Havilland, who

wore a Dior wedding dress in the 1956 film *The Ambassador's Daughter*. Grace Kelly chose a Dior gown to announce her engagement in 1956, and the roll call of big-name actresses continued with Marilyn Monroe, Ingrid Bergman, Sophia Loren (who reputedly spent hours looking at dress samples, cigarette in hand) and Rita Hayworth, who wore Dior to the premiere of *Gilda*. Elizabeth Taylor was a long-time fan of the designer both before and after his death, remaining a loyal customer of the House of Dior; in 1961, she accepted her Best Actress Academy Award wearing a Dior dress and even commissioned matching outfits for herself and her young daughter, Liza.

RIGHT Dior dressed many Hollywood actresses on and off screen. Here, he fits Jane Russell in 1954 with a "Mazette" ensemble from his "H" line, comprising a wool crepe dress and mink fur collar.

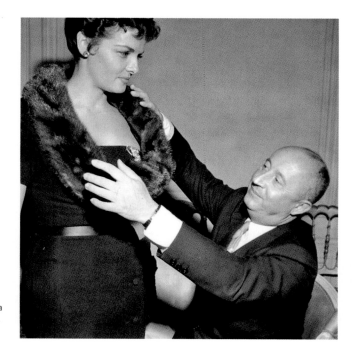

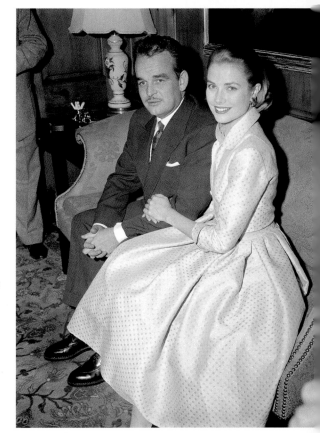

RIGHT Grace Kelly appeared in one of Dior's tailored, elegant gowns when she announced her engagement to Prince Rainier of Monaco in 1956.

OPPOSITE Olivia de Havilland is shown here with Dior when she wore one of his wedding dresses for *The Ambassador's Daughter* in 1956.

Dior dresses have since regularly appeared on the red carpet. Nicole Kidman wore a fitted bespoke gown, designed by the newly appointed John Galliano, in a striking and controversial chartreuse to the 1997 Oscars. Galliano later commented, "Nicole looked like a goddess and showed the world she believed in me." To accept her 2013 Best Actress Oscar, Jennifer Lawrence wore a romantic pale pink and white floral-embossed silk Dior ball gown designed by Raf Simons, which she famously tripped over as she walked up to

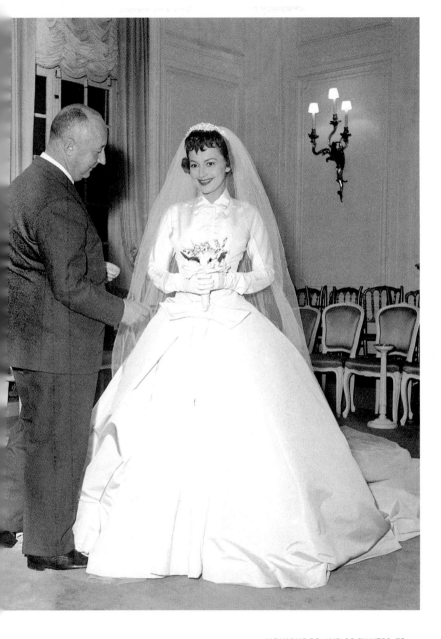

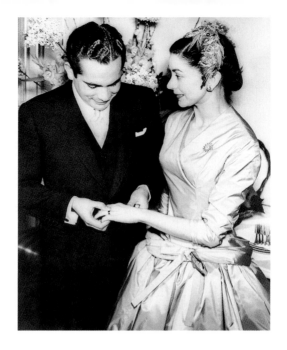

ABOVE When she married in 1955, prima ballerina Margot Fonteyn wore a knee-length silk taffeta Dior wedding gown with a crossover neckline, an "H"-line lengthened and tailored waist, three-quarter sleeves and a full skirt.

the stage. These are the most exquisite of all haute couture gowns, and they are laboured over for days – or 1,000 hours in the case of the raffia-embroidered dress, designed by Maria Grazia Chiuri to look like a "little French garden", that Nicole Kidman wore to the 2017 Cannes Film Festival. And they come with a hefty price tag: Charlize Theron's couture gown for the 2013 Oscars cost $100,000.

The glamour Hollywood has imparted to the Christian Dior label since the 1950s has filtered down through the brand to today's ready-to-wear, perfume, cosmetics and accessories, making it one of the world's most successful luxury brands. This is thanks in no small part to the choice of beautiful, elegant actresses, all of whom epitomize the Dior woman, to represent the label. These have included Jennifer Lawrence, who appeared in a campaign for the

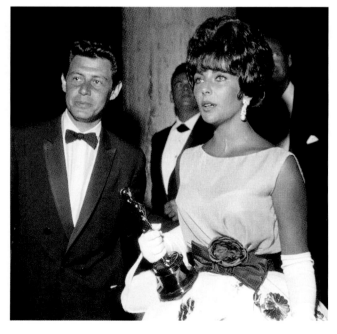

"Miss Dior" handbag; Marion Cotillard, who became
the face of the brand in 2009; Charlize Theron, who was
signed by John Galliano in 2003 and is the face of the *J'adore*
fragrance; and Natalie Portman, who represents the label's
beauty and fragrance line and who starred in the short
advertising film *La Vie en Rose*, directed by Sofia Coppola.

OPPOSITE LEFT
Charlize Theron wore a
striking midnight-blue
strapless fishtail gown by
John Galliano for Dior to
the 2005 Golden Globes.

OPPOSITE RIGHT
Marion Cotillard, one of
the faces of Dior, wore a
stunning sequinned blue
gown with full net skirt,
cinched at the waist by
a patent belt, to the 81st
Academy Awards in 2009.

RIGHT Natalie Portman,
who represents Dior
fragrance and cosmetics,
wore this Dior haute
couture red with black
polka dots strapless silk
organza gown to the 84th
Academy Awards in 2012.

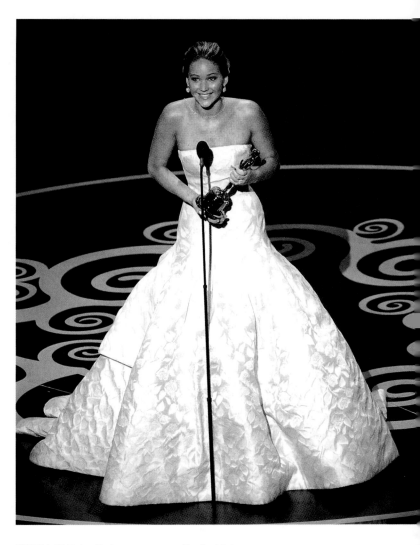

ABOVE In 2013, Jennifer Lawrence accepted her Best Actress
award for *Silver Linings Playbook* wearing a pale pink and white
floral-embossed silk Dior ball gown designed by Raf Simons, which
she famously tripped over as she walked up to the stage.

ROYALTY AND DEBUTANTES

BOVE Princess
Margaret had the
erfect figure for Dior
clothes and visited
he atelier in Paris to
ave private views of
he new collections.

At age 21, Dior spent several months in London and later
wrote in his autobiography: "There is no country in the
world besides my own … I like so much." Of dressing English
women, he said: "I find them amongst the most beautiful and
distinguished in the world. When an English woman is pretty
she is prettier than a woman of any other nationality."

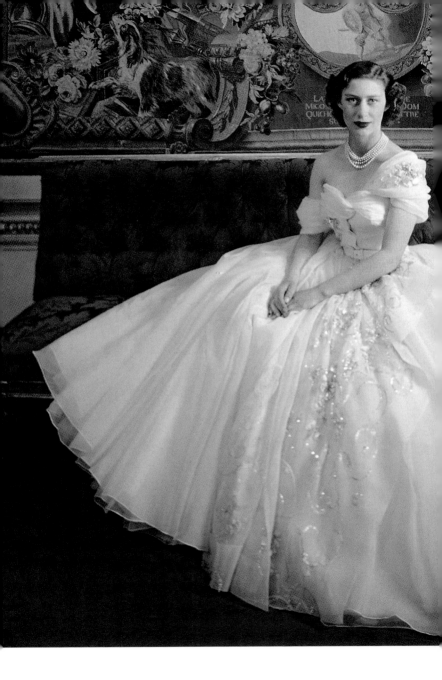

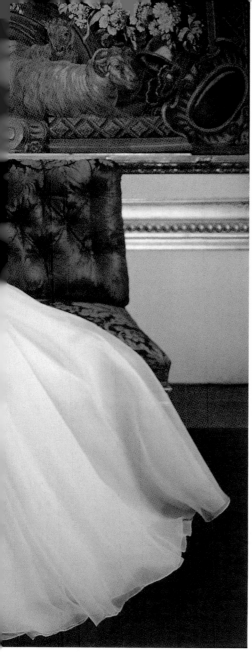

LEFT Princess Margaret sat for society photographer Cecil Beaton for her official twenty-first birthday portrait in July 1951, wearing an exquisite off-the-shoulder white Dior gown featuring draped tulle, intricate embroidery, sequins and pearls.

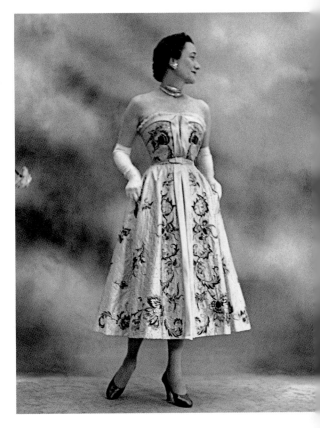

RIGHT The Duchess of Windsor, who lived in Paris, was well known for her impeccable dress sense. This 1951 photograph of the exiled royal, wearing a Dior ball gown with beaded flowers, appeared in American *Vogue* magazine.

OPPOSITE Christian Dior had admired Josephine Baker for years, watching her perform at the Folies Bergère long before he became a fashion designer. The entertainer wore his gowns on stage for her 1951 tour of the United States.

Dior's first showing in London was his second collection in the autumn of 1947. It was a sumptuous affair at the Savoy hotel and the next morning, Dior was invited to give a private showing to the then-Queen; Princess Margaret; Marina, Duchess of Kent; and the Duchess' sister Princess Olga of Yugoslavia. A confirmed royalist, Dior noted the "elegance" and "graciousness" of the Queen, but it was Princess Margaret who captured the very essence of the beautiful English rose. He described her as "a real fairy-

tale princess, delicate, graceful, exquisite … [who] knew exactly the sort of fashions that suited her fragile height and Titania-like figure". The admiration was mutual – the young princess had a keen interest in fashion and the finely tailored, hourglass-shaped designs of the New Look were perfectly suited to her.

Princess Margaret was the most glamorous and lovely of the young royals, and in July 1951 she sat for society photographer Cecil Beaton for her official 21st birthday

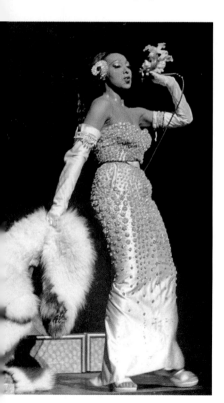

portrait wearing an exquisite off-the-shoulder white Dior gown featuring draped tulle, intricate embroidery, sequins and pearls. The aesthetic was pure New Look, with a tiny waist and extravagantly full skirt. The princess became a loyal client of the House of Dior, as did other members of the British aristocracy. The author Nancy Mitford, who lived in Paris, was smitten by the New Look collection and purchased the black "Daisy" suit, which she described as: "Simply, to my mind, perfect."

Dior dresses were also sought after among debutantes, as they were required to wear new outfits for every social occasion in the busy coming-out season, and the "debs" were keen to make an impression by wearing the latest fashions. In 1953, a debutante fashion show was

organized in aid of the NSPCC (the National Society for the Prevention of Cruelty to Children) at the Berkeley hotel. The final piece of the collection, the wedding dress, was an exquisite creation made from fine muslin and embroidered with white flowers and delicate metal leaves. It was later presented to a delighted Jane Stoddart, a 19-year-old bride with the classic hourglass figure of the Dior woman, who wore the dress to her London wedding.

Charity fashion shows remained an excellent way of publicizing Dior's designs in Britain, where the press had a greedy appetite for the glamorous upper classes. In 1954, the Duchess of Marlborough organized a show in aid of the British Red Cross at Blenheim Palace with Princess Margaret as the guest of honour.

Thirteen carefully selected models paraded a selection of Dior's new "H" line Autumn/Winter 1954 collection in front of almost two thousand guests. It was one of the few fashion presentations that Dior attended as a guest. As a tribute, he was made an honorary member of the British Red Cross and presented with a diploma by Princess Margaret. After the show, he was mobbed by a crowd of Red Cross nurses clamouring for autographs. In his autobiography, Dior wrote glowingly of his impression of the grand Blenheim Palace, although admitted to feeling slightly awkward showing French fashion among tapestries celebrating the defeat of the French, in the home built for the Duke of Marlborough: "At any moment I expected his indignant ghost to join the line of mannequins!"

A more recent member of the British royal family who favoured the brand, as avidly followed by the press as the young Princess Margaret, was Princess Diana. She often chose elegant suits from the fashion house and, in 1995, she

OPPOSITE TOP
Dior was very popular among the British upper classes, and in 1953, a debutante fashion show was organized for the NSPCC at The Berkeley hotel.

OPPOSITE BELOW
Charity fashion shows were an excellent way to publicize Dior designs, especially with royals like Princess Margaret present. This 1954 Blenheim Palace show in aid of the British Red Cross saw the models parade among tapestries celebrating Marlborough's defeat of the French, a juxtaposition Dior found ironic.

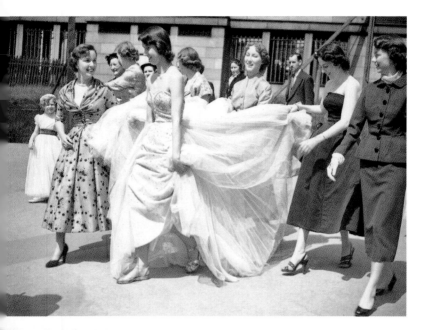

had the iconic "Lady Dior" handbag named for her. But it was Diana's choice of John Galliano's first-ever creation for Dior that stole the limelight: a controversial slip-like peacock-blue silk dress with lace detailing that the princess wore to the Met Ball in New York in 1996. Rumour has it she almost didn't wear the dress, worrying that the then-14-year old Prince William would be shocked to see his mother wear something so revealing.

Plenty of other royals have chosen Dior designs too, the restrained elegance of the label perfectly suiting diplomatic and state occasions. Princess Charlene of Monaco frequently chooses Dior gowns for balls and galas as well as simple shift dresses or suits for other public occasions. Queen Rania of Jordan, renowned for her effortless sense of style, is another fan, and Queen Mathilde of Belgium often appears in the brand's timeless suits, so redolent of the 1950s. The younger generation – including fashion model and royal Lady Amelia Windsor, a firm fixture on the Dior front row – aren't afraid to showcase some of the label's more risqué designs including the iconic white-with-black-polka-dots transparent dress, complete with visible branded Dior underwear, from the Spring/Summer 2018 show. As proof that Dior is a failsafe label for new royals hoping to strike the stately tone so associated with the British monarchy, Meghan Markle, now the Duchess of Sussex, turned to the brand as she joined the royal family. For the RAF centenary service at Westminster Abbey, she chose a perfectly tailored Maria Grazia Chiuri black satin dress with a boat neck, nipped-in waist and flared skirt that felt like a modern take on the iconic dresses of Christian Dior's groundbreaking New Look collection.

OPPOSITE In 1996, Princess Diana wore John Galliano's first-ever creation for Dior to the Met Ball in New York. The controversially slip-like peacock-blue silk dress with lace detailing caused outrage among some commentators, who felt it was too provocative for a member of the royal family.

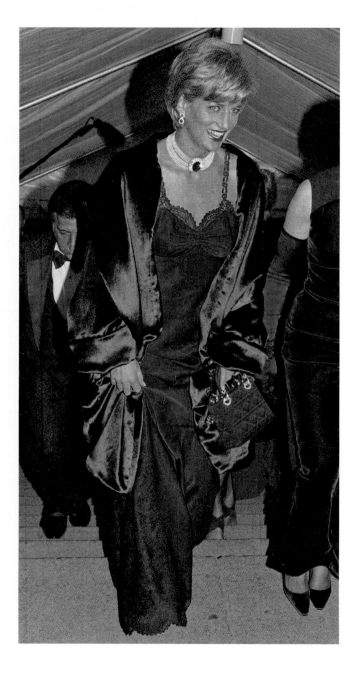

Dior
Without Dior

MAINTAINING DIOR'S LEGACY

Christian Dior died after heading his eponymous house for just 10 years but his legacy is such that the designers who have succeeded him have remained true to the original tenets of the New Look: masterful cut and tailoring, celebration of the female form, exotic and historical influences, and theatrical presentation.

YVES SAINT LAURENT 1957–1960

Algerian-born Yves Saint Laurent showed a prodigious talent for fashion design even as a student in Paris, where he won several prestigious prizes at the age of just 18. French *Vogue* editor Michel de Brunhoff took the young designer under his wing, immensely impressed when Saint Laurent showed him fashion sketches that bore close similarities to ones drawn by Dior himself featuring the new "A" line silhouette. An introduction was made in 1955, and Dior immediately hired the younger man. Saint Laurent soon started submitting designs for the haute couture collections, and by the mid-1950s, he had become invaluable to Dior.

OPPOSITE Yves Saint Laurent poses by the model schedule in the atelier of the House of Dior, 1958.

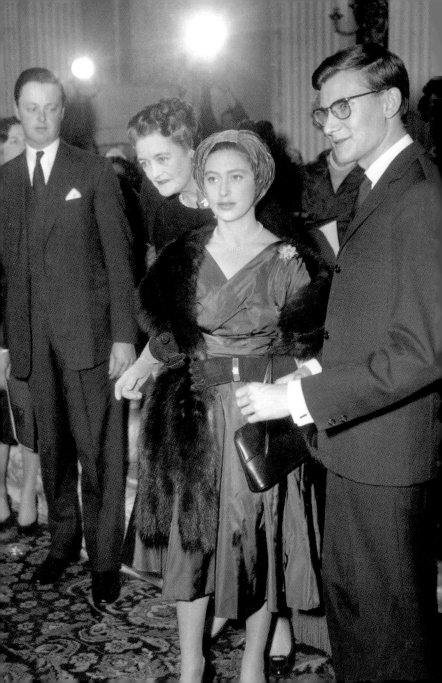

RIGHT For his Dior debut, Yves Saint Laurent introduced the "Trapeze" line – a beautifully elegant collection dedicated to the late designer, which received rave reviews.

OPPOSITE A year after Dior's untimely death, Yves Saint Laurent followed in his footsteps by taking his collection to Britain for a second charity fashion show in aid of the Red Cross at Blenheim Palace. Princess Margaret presented the designer with a Red Cross Badge of Honour, as she had done for Christian Dior.

In August 1957, Dior met with Saint Laurent's mother to tell her that he had chosen her son to succeed him as head designer. Given Dior's relatively young age, the remark was mystifying, and yet fate intervened. Later that year, at just 21 years old, Yves Saint Laurent found himself head of the famous couture house.

Saint Laurent's first collection for Dior, which was called the "Trapeze" line and dedicated to the late designer, was a huge success. The new head designer built on Dior's original "A" line silhouette to present a collection that was beautifully balanced, with an elegant symmetry between wide, scooped necklines and billowing, full skirts. The relief among

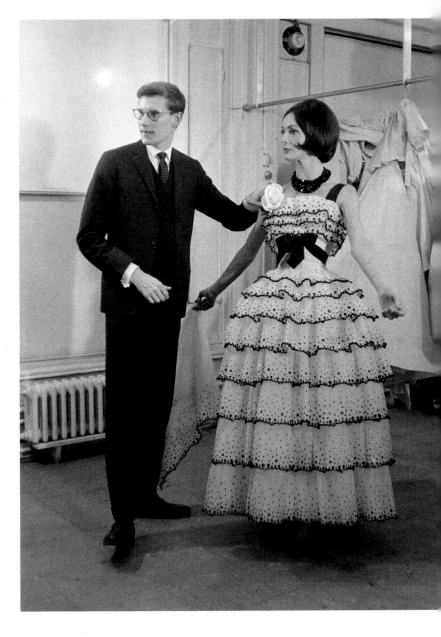

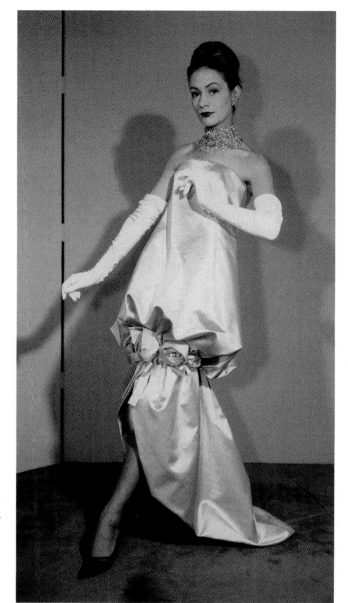

OPPOSITE Yves Saint Laurent puts the finishing touches on an evening gown for his Spring/Summer 1959 collection.

RIGHT Yves Saint Laurent experimented with modern fashions, including the hobble skirt shown here as part of this blue satin evening gown for his Autumn/Winter 1959/60 collection.

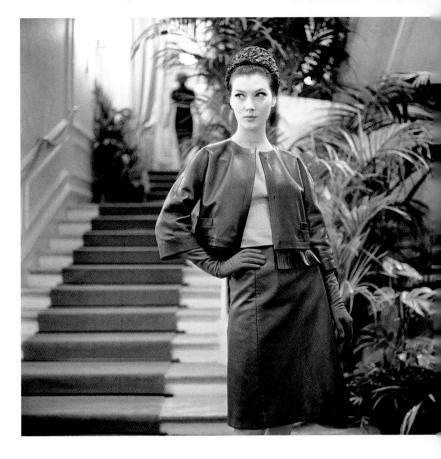

ABOVE Towards the end of his short tenure at Dior, Yves Saint Laurent looked to beatniks and other youth culture for inspiration, which was not well received by those who respected the traditional elegance of Dior.

the fashion press was palpable, with *The New York Times* commenting: "Rarely does a hoped-for miracle come off just on time … today's magnificent collection has made a French national hero of Dior's successor, 22-year-old Yves Saint Laurent, and comfortably assures the future of the house that Dior built."

However, Saint Laurent's tenure was short-lived, as he resisted the slow, gentle fluctuations in style and hemline that was expected of a genteel couture house such as Dior.

Clients and press alike were scathing of his revolutionary new designs, including hobble skirts and beatnik-influenced pieces. In retrospect, Saint Laurent's creations were prescient, but he spoke to the future, not the present. By taking inspiration from youth culture and reflecting it in haute couture, he inevitably alienated himself from the respectability of the Dior brand. An immensely exciting and talented designer, he went on to achieve enormous success, but unfortunately Dior was not the right house in which to showcase his fashion vision. When the designer was called up for military service in 1960, he was replaced by Marc Bohan.

MARC BOHAN 1961–1989

The House of Dior could not have found a designer more different to Yves Saint Laurent than Marc Bohan. Older by a decade and far more experienced in the world of haute

BELOW Marc Bohan arriving in New York in 1955 with 10 Dior models. Little did he suspect that five years later, he would be head of the haute couture house.

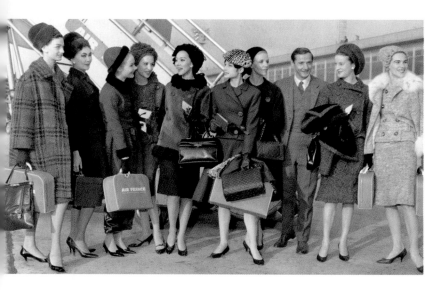

couture, Bohan was deeply respectful of its traditions. The designer was no stranger to the label either. In 1957, having admired Bohan's work at houses such as Molyneux and Jean Patou, Dior asked him to head up the brand's New York operation. Dior died before he could appoint Bohan to this role and, with tension brewing between Bohan and Yves Saint Laurent, the new head designer was reluctant to honour the offer. Bohan was well respected by other partners at Dior, so instead moved to Dior London and when the volatile Saint Laurent was drafted for military service, he was replaced by the steadfast Bohan. The decision was an astute one. Clients and buyers were troubled by Saint Laurent's radical new fashion direction – ironically, given the

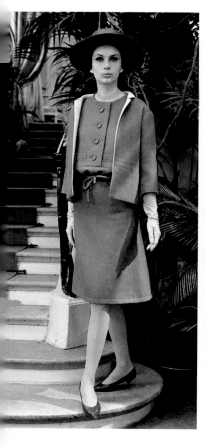

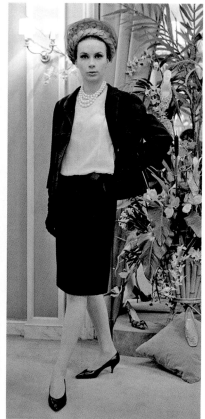

furore caused by Dior's original New Look – because Dior was now seen as a timeless label to trust for style classics.

Bohan spent 29 years as head of Dior, and in that time, the fashion and haute couture industries changed unrecognizably. Not only did fashions vary wildly through the 1960s and 1970s, but also the practice of selling original Paris designs to department stores for reproduction on a large scale was replaced by ready-to-wear. These additional

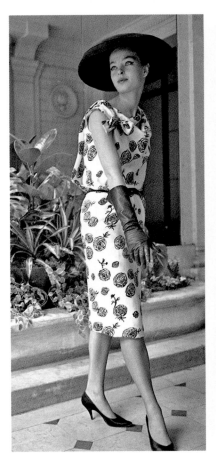

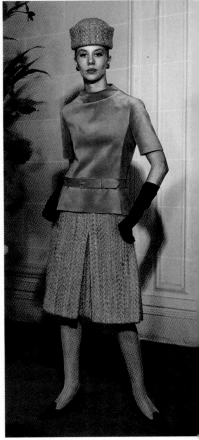

collections, targeted at a wider buying public and imbued with all the cachet of the designer label, would become a major source of revenue for couture houses. Ready-to-wear collections were shown two weeks before the grandeur of haute couture; by the 1970s, the number of designers presenting these shows became so high that, in 1973, the regulatory Chambre Syndicale du Prêt-à-Porter des Couturiers et des Créateurs de Mode (soon to be known as

OPPOSITE LEFT
This simple, slim-
belted floral dress
with neck-bow detail,
perfectly accessorized
with a wide hat, long
gloves and pointed
heels, is typical of the
wearable and elegant
outfits that gained
Bohan such a loyal
clientele.

OPPOSITE RIGHT
A 1963 lilac, belted
drop-waisted top with
skirt and matching
hat in fashionable
tweed combines the
elegance of Dior with
the fashions of the
1960s.

RIGHT Bohan had a
particular talent for
designing evening
wear, such as this
exotically beaded,
sleeveless Byzantine-
inspired dress from
the late 1960s.

RIGHT AND OPPOSITE
Some have accused Marc Bohan of playing it too safe at Dior, but he navigated the changing fashions of the 1960s and 1970s with aplomb, unafraid to use bold patterns and colours. These psychedelic outfits from 1966 (right) embody 1960s style, while this flowing pink gown (opposite) from Autumn/Winter 1977–78 is very boho-luxe.

Paris Fashion Week) was founded. It was Yves Saint Laurent who launched one of the first ready-to-wear collections with his own Rive Gauche boutique, but Bohan followed soon after, launching Dior's "Miss Dior" line in 1967. Other changes followed, with the launch of "Baby Dior" in 1967 and "Dior Homme" menswear in 1970. Bohan also oversaw the expansion of Dior's fragrance business. In 1969, Dior presented its first complete line of cosmetics and the brand

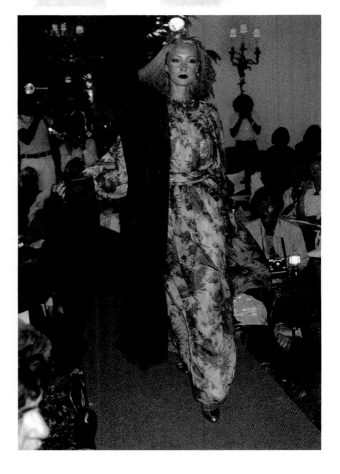

had at last achieved Christian Dior's goal to provide for every part of a woman's appearance.

Marc Bohan never wavered from the foundations of Dior's design ethos. His clothes were always masterfully cut with a sculptured precision in their silhouette, and he was modern without being flashy. His first collection in 1961, titled the "Slim Look", took the 1920s influence that so many designers were exhibiting that season but

ABOVE A 1975 shot of Jerry Hall wearing a blue one-shouldered satin column dress with luxurious feather trim shows Bohan's tailored glamour at its best.

gave it a fresh, young aesthetic, streamlined and simple and most importantly, infinitely wearable. *Women's Wear Daily* commented: "Bohan has done the impossible: he is a big commercial success and respected by the fashion intellectuals".

Bohan may not have had the fashion genius of Yves Saint Laurent, or even of the later John Galliano, but he provided

...GHT Like Yves Saint ...urent before him ...d Raf Simons after, ...ohan experimented ...ith androgynous ...yles, and in the ...980s, presented a ...ide-shouldered long ...uxedo jacket offset ...ith killer heels and ...n accent of red.

...AR RIGHT ...Marc Bohan oversaw ...ne launch of the ...abel's first menswear ...ne, "Dior Homme", ...n 1970.

a timeless elegance essential to the longevity of a house like Dior. He took the fashions of the day and elevated them to haute couture. His particular talent for designing evening wear saw the creation of stunningly embellished gowns in exotic fabrics, of which Dior himself would have been proud. But Bohan's most formidable skill, which enabled him to maintain the largest number of haute couture clients

ABOVE The 1967
opening of "Miss Dior",
a ready-to-wear line
by the couture house,
proved hugely popular
with shoppers crowding
into the Paris store.

OPPOSITE In 1967,
"Baby Dior" was
opened by Princess
Grace of Monaco;
the line provided
matching Dior outfits
for mothers and their
daughters.

of any house in Paris, lay in pleasing his female customers. "Don't forget the woman" was his motto, and many devoted customers flocked to the new designer. Elizabeth Taylor bought 12 dresses from his debut collection and Jacqueline Kennedy Onassis, Sophia Loren and Princess Grace of Monaco all turned regularly to Dior for Bohan's effortless sense of style.

Bohan left Dior in 1989 first to design for Norman Hartnell, and later to concentrate on designing under his own name.

GIANFRANCO FERRÉ 1989–1996

In 1984, Dior was bought by Bernard Arnault, the French financier who would go on to become the wealthy and influential chairman of LVMH[1], the world's largest luxury goods company. Gianfranco Ferré was the first designer to be appointed by Arnault as he sought to restore the fortunes and boost the international reputation of the Dior label.

RIGHT Ferré received a De D'Or award for his first collection, which featured immaculately tailored suits worn with top hats and was inspired by the Ascot finery of Cecil Beaton's costumes from the 1964 film *My Fair Lady*.

OPPOSITE For his 1989 debut collection, Ferré stayed true to the New Look aesthetic, creating ball gowns in sumptuous fabrics with florals printed or embroidered onto the fabric with added embellishments and cascading flowers.

1 In 1984, Moët Hennessy – Louis Vuitton SE (LVMH), the luxury goods group headed by French billionaire Bernard Arnault, bought the Boussac company, then about to go bankrupt, giving the company the fashion label which quickly became the cornerstone of its empire. In 2017, LVMH finally bought the 25.9% of Dior that it did not own, consolidating the brand.

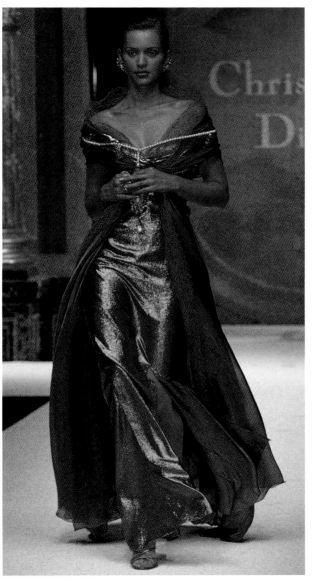

LEFT Like Dior himsel[f]
Ferré loved glamour,
epitomized by this
long, gold sheath
dress made from
velvet panne with a
taffeta silk cape from
his Autumn/Winter
1993/94 haute
couture collection.

Ferré was a somewhat controversial choice. He was an Italian (at a time when the rivalry between French and Italian fashion was at an all-time high) with a background in ready-to-wear, not haute couture. Nevertheless, Ferré was a natural fit for the house. Trained as an architect (he became widely known as "the architect of fashion"), a career Dior himself once considered, Ferré understood the importance of a garment's underlying structure and form and shared much of Dior's aesthetic. Both men idolized their stylish mothers, celebrated the feminine and found inspiration in travel – Ferré spent three years studying in India in the early 1970s and was heavily influenced by the colours and traditions he found there. But perhaps the most important similarity was a love of glamour, theatre and overtly stylized silhouettes rich with embellishment and decoration. These all came easily to Ferré, who had produced a collection inspired by *La Dolce Vita* for his own label in the 1980s.

BELOW Before the new collections, Ferré would spend three days locked in the Dior salon going through thousands of items, including shoes, jewellery, gloves, scarves and hats, to choose the perfect accessories for each outfit.

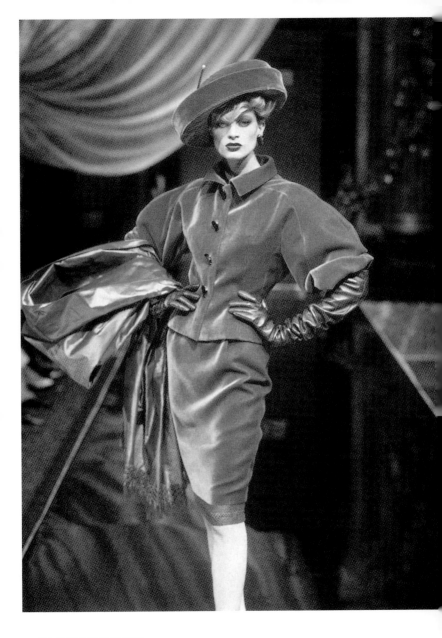

Gianfranco Ferré's experience in ready-to-wear was important too. Haute couture was still the glamorous face of Dior, but relatively few women could afford the hefty price tags these outfits carried. The theatricality of the Paris shows became a marketing tool, while ready-to-wear, menswear and diffusion lines into accessories, fragrance and cosmetics provided the financial ballast. Ferré, with his background in jewellery design, ready-to-wear, menswear and accessories for his own label was well placed to steer Dior though this shift in the fashion industry.

Ferré's first collection for Dior was called "Ascot-Cecil Beaton", and was inspired by the costumes created by Beaton for the 1964 film *My Fair Lady*. By combining Dior's love of Edwardian style with the Ascot finery of Beaton's film, Ferré found a masculine foil to the femininity of decorative Edwardian dresses. He described his look as juxtaposing "austere masculine fabrics – tweed, barathea, flannel, Prince of Wales check – with exquisitely feminine white blouses in silk, voile and organza". Models wore suits and matching top hats in Dior's beloved muted grey, accessorized with an enormous bow that became Ferré's trademark. Evening wear was as sumptuous as ever, with floor-length dresses made from silk faille, duchesse satin and organza with embroidered pearls and jewels. And as a tribute to Dior's love of flowers, roses, lilies of the valley and country flowers were printed onto fabrics, pinned corsage-style or cascaded extravagantly from ballgowns. The clothes were as perfectly constructed as Dior himself would have demanded. American *Vogue* summed up Ferré's debut as "a matter of Dior discipline and Ferré flourish". The designer was awarded the prestigious Dé D'Or (Golden Thimble) for his first collection.

During his seven-year tenure at Dior, Ferré stayed

OPPOSITE Beautifully tailored outfits were given Ferré's trademark oversized flourishes, seen here in the oversized sleeves, long gloves and large matching hat from his Autumn/Winter 1995 haute couture show.

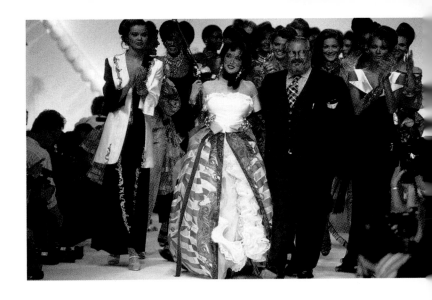

true to the New Look aesthetic, with its curvaceous silhouette, immaculate structure and craftsmanship and use of imaginative textiles and fabrics. The strong lines of his creations, referencing the tightly cinched waist and exaggeratedly curved skirts, were as sculptural as Dior's original designs. Ferré freely acknowledged how much Dior' revolutionary New Look underpinned his own collections, commenting: "I don't want to live with a ghost, but I respect the couture tradition." Ferré did leave his own mark on the house with oversized bows and equally outsized cuffs and lapels, influences from the East and exaggerated elements in shoulders, flared sleeves and billowing skirts. Looking back on his collections, there is a strong sense of late-1980s and early-1990s fashion, not an era readily compared to the elegance of the 1950s. It is testament to Ferré's skill as a designer that he managed to create modern designs that still retained an echo of Dior's original New Look. Ferré left Dior in 1996 to focus on his own label.

JOHN GALLIANO 1996–2011

Almost exactly 50 years after Christian Dior presented his groundbreaking New Look, a similar visionary took over the reins at the House of Dior: British designer John Galliano, whose first haute couture collection hit the catwalks in January 1997. Galliano had already proved his credentials at Givenchy – where, in 1995, he became the first British designer to lead a French couture house since the end of World War II – before being moved to Dior in 1996 by LVMH owner Bernard Arnault.

The move could not have been more apt. Galliano had long revered the designs of Dior and shared many of the same visions. Both men had travelled widely, were particularly influenced by exotic cities and cultures and had

BELOW In 1996, Galliano took over at Dior, immediately stamping his personality on the label by designing flamboyantly feminine gowns inspired by Christian Dior's own love of the exaggerated female form.

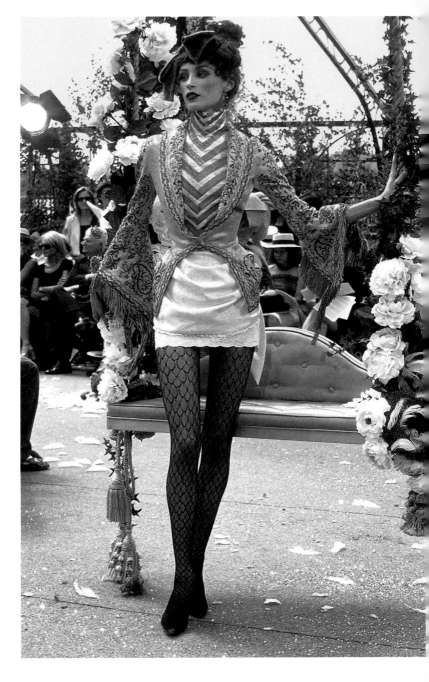

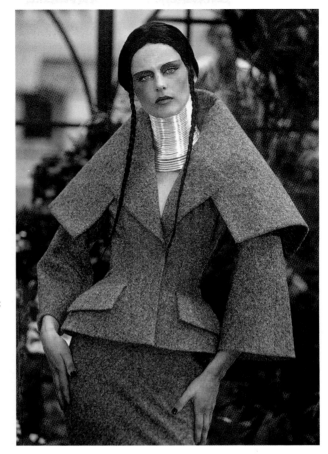

OPPOSITE For his
Autumn/Winter
1997/98 haute
couture collection,
Galliano gave his
own twist on Dior's
beloved Belle Époque.

RIGHT Galliano had a
talent for reinventing
Dior's classic designs
in shocking ways.
Here, he takes the
New Look "Bar" jacket
and exaggerates it in
a design inspired by
"the Ndebele women
who traditionally
envelop themselves
majestically in
blankets". The look
is completed by a
choker that echoes
the tribe's neck rings.

a love of historical romanticism. The latter was abundantly clear in Galliano's lauded Central St Martin's graduate show, which was titled "Les Incroyables" and was inspired by the flamboyant eighteenth-century dandies of the French Revolution. Galliano also shared Dior's obsession with the exaggerated female form, and his masterful skill in creating almost architecturally structured clothes echoed that of the legendary designer.

On his appointment, Galliano declared, "It is the greatest house in the world. To be given the reins of the house is something I would never have believed could happen." In homage to Christian Dior's first show, Galliano staged his debut haute couture collection for the label at the Grand Hotel in Paris, where a larger-than-life version of Dior's original salon had been built, complete with dove-grey drapery and a grand central staircase. The show itself harked back to the French designer's love of the Belle Époque, a halcyon time epitomized by Dior's mother's style and romanticized in his future collections, juxtaposed with Galliano's fascination with the Maasai people. Shapes from the New Look, including the iconic "Bar" line with its tiny waist and flared hips, were used by Galliano, but softened and shortened. The "S" line silhouette was featured frequently, presented in vibrant colours. Like Dior, Galliano relied heavily on accessories to create a look, and that first show featured dramatic Maasai-inspired breastplates, bracelets and plate-collars. It was a forceful arrival that set the stage for the next 15 years.

John Galliano had remarkable skill in blending East and West: his first ready-to-wear collection, nicknamed "Dior Pin-ups", was inspired by Hollywood icons such as Marilyn Monroe and Brigitte Bardot as well as Chinese pin-up models from the 1930s. Future shows featured Raj-inspired Mata Hari evening dresses and imagined a meeting between Wallis Simpson and Pocahontas. His love of theatre meant that his haute couture shows – complete with cutting-edge set design and models made into imaginary characters – were more akin to watching a performance than a fashion show.

Throughout his time at Dior, Galliano pushed the boundaries of fashion design. While remaining true to

OPPOSITE Like Dior, Galliano was inspired by different cultures, and his Autumn/Winter 2001/02 collection took inspiration from Tibet.

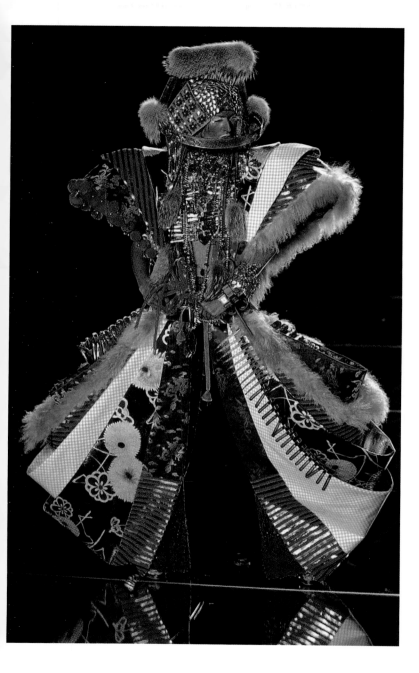

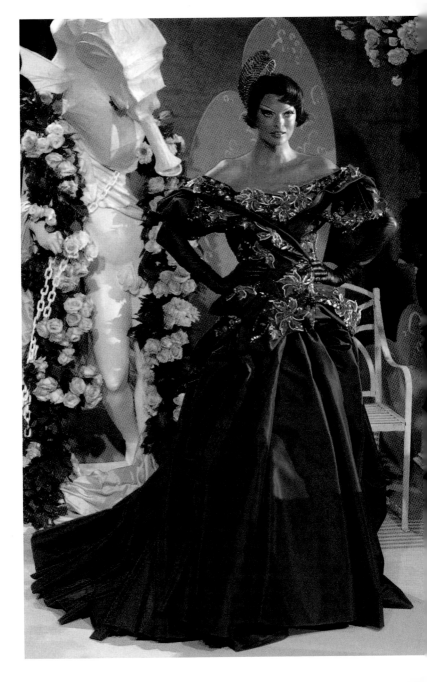

the label's Edwardian aesthetic, his collections variously introduced sportswear, Russian and Chinese military uniforms, nods to Communism, and surrealist, Dali-esque tailoring in which jackets were worn back to front. Female emancipation was a strong theme, with warrior-like models stalking the runway, and his social commentary was most evident in his controversial 2000 haute couture show "Clochards", which was inspired by Paris's homeless population and saw newspaper-printed silk dresses deconstructed and pinned with rags.

There is no doubt that throughout Galliano's tenure at Dior, he created a truly remarkable variety of designs. The British designer never forgot the ethos of Christian Dior himself, always paying incredible attention to detail in the tailoring and embellishment of his own designs, while his eclectic interests and inexhaustible creative energy made him the most flamboyant of designers at the House of Dior. Galliano's time at Dior came to an abrupt end in 2011 when he was fired after accusations emerged that he had twice made anti-semitic and racist remarks to patrons of a Paris bar. Blaming his drug and alcohol addictions, he was later charged and fined 6,000 Euros.

BILL GAYTTEN 2011–2012

Bill Gaytten is not a name usually included in the roll call of designers for Dior, as he was only a temporary replacement. However, it is worth acknowledging the job he did holding down the fort after the scandal of John Galliano's departure. Gaytten had worked alongside Galliano for 23 years, first at the designer's own label, then at Givenchy and finally at Dior. His role as studio head was essentially overseeing the creation of the garments, but not their design, so the

OPPOSITE For the 60th anniversary of Dior, Galliano created a tribute collection called "The Artists' Ball", designing extravagant dresses for it, such as this red ball gown, worn by Linda Evangelista, with a curvaceous silhouette and beaded, floral embellishments.

appointment was a rude awakening for the reserved Gaytten who was more used to being behind the scenes than thrust into the limelight. He took over just four days before the Autumn/Winter 2011 ready-to-wear collection was due to hit the catwalk, but stewarded Galliano's final collection and stayed on to design two haute couture and two ready-to-wear collections.

Gaytten was not treated particularly well by the fashion press, which was clamouring for a high-profile design talent to be appointed as creative director. Nevertheless, he stuck close to the fundamental tenets of the Dior brand, presenting collections based on the New Look and Galliano-style exaggerated silhouettes that were unimpeachable in their design technique. Gaytten's colour palette was restrained and his designs cautious, but he provided a much-needed steadying hand as the repercussions of Galliano's antisemitic outbursts and the revelations of his drink and drug addictions rocked the reputation of the House of Dior.

RAF SIMONS 2012–2015

During the year that Bill Gaytten headed Dior, there was much speculation as to who would take over from John Galliano as creative director, with names like Marc Jacobs and Phoebe Philo in the mix. So different from the theatrical Galliano, Belgian-born designer Raf Simons was not immediately hyped as a contender, although he had a background in industrial design and had generated a great deal of interest since his arrival on the fashion scene. He started his career as a furniture designer and, rather like Dior himself, was fascinated by contemporary art. In 1990, Simons was impressed by a fashion show by fellow Belgian Martin Margiela, an eccentric designer who deconstructed

OPPOSITE In his debut collection, which became the focus of the documentary *Dior et Moi*, Simons recreated the perfect craftsmanship and essential simplicity of Dior's own first collections.

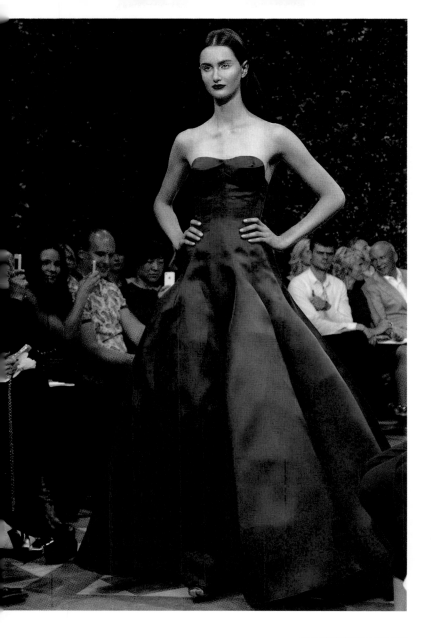

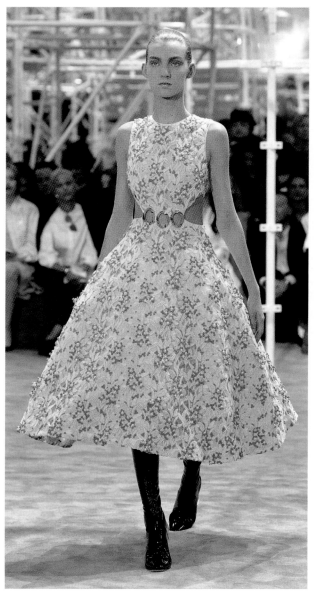

LEFT In a floral dress with the nipped-in waist and full, flared skirt of the New Look, Simons literally deconstructs the legacy of Dior with a cut-out pattern at the waist in place of the classic belt.

OPPOSITE In Simons's Spring/Summer 2015 haute couture collection, named "Moonage Daydream" in homage to David Bowie, he explained his experimental mix as a sensory overload embracing "the romance of the 1950s ... the experimentation of the 1960s and the liberation of the 1970s".

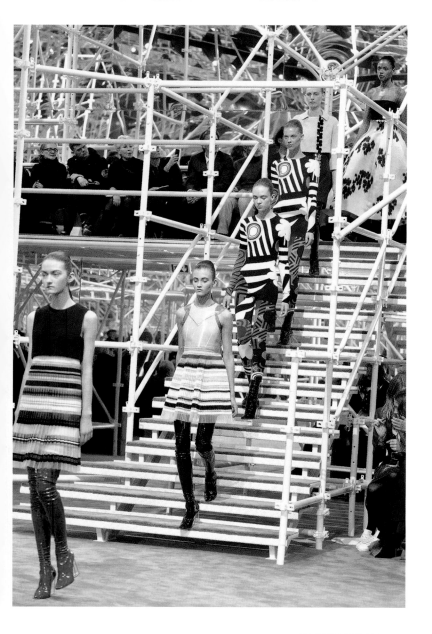

fashion – creating haute couture outfits from unusual source including second-hand fabrics, discarded canvases, old wigs and silk scarves. The Margiela show, held in a children's playground rather than a grand salon, intrigued Simons. He saw how couture fashion could exist – outside the glamour and parties – and be experienced on an intellectual emotional plane, much like a work of art.

Simons had no formal training, launching his fashion career with an eponymous menswear label in 1995. His early influences came mainly from youth culture within music, with sources as varied as niche hardcore techno, German electro bands and British rock. His first foray into womenswear came when he was appointed by the German label Jil Sander to create a ready-to-wear line. Sander's utilitarian, minimalist aesthetic had won the brand a core of loyal fans, and her innovative use of fabrics helped define the fashions of the day. But her modern, understated silhouette needed reinvigorating – and Raf Simons did just that, bringing energy to the label. His exhaustive research into precise cuts, use of brightly coloured synthetic materials and his inclination towards ergonomic shapes was revolutionary. Combined with his passion for edgy music and art and his awareness of contemporary culture, Simons's aesthetic spoke to a new generation.

When he joined Dior in 2012, Simons looked back into the Dior archives, like so many of his predecessors. He had used mid-century haute couture silhouettes (albeit reinterpreted in synthetic neons) at Jil Sander, and for his debut collection at Dior, he took the iconic "Bar" jacket and teamed it not with the demure, flared skirt of the 1950s but with narrow trousers. It was an inspired move, a feminine take on masculine dressing, fittingly recalling Yves

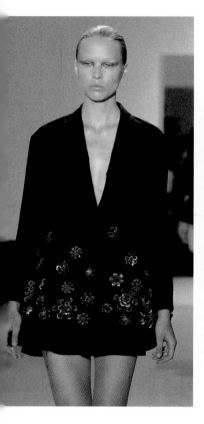
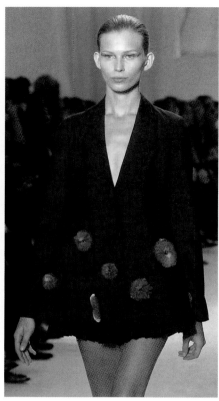

ABOVE By teaming
tailored, floral-
embellished jackets
with ultra-mini skirts,
Simons presented
a different take on
Dior's lengthened
silhouette.

Saint Laurent's 1966 revolutionary "Le Smoking" tuxedo for women. Simons deconstructed the legacy of Dior – sometimes literally, as when he presented his take on a floral Dior ball gown but truncated it at the hip to appear more like a bustier top, or when he paired a ball gown featuring a billowing, tulip-like skirt, full of Edwardian romance, with a sportswear-like semi-transparent top.

Raf Simons's first collection for Dior was breathtaking in its both its intellect and execution. Here was an industrially trained designer with a passion for modernity managing to take the classic lines of the Dior archives and reinterpret them in a completely different way. It was a "new look" all over again.

In April 2014, a documentary about the making of the collection, directed and written by Frédéric Tcheng, premiered at the Tribeca Film Festival. *Dior et Moi* revealed as never before the level of artistry and skill that is involved in putting on a haute couture show. From Simons's extensive research of the Dior archives through the design process between the designer and his collaborators to his relationship to the ateliers (some of which had been making the details of Dior's collections by hand for more than 40 years), the documentary was revelatory. Simons comes across as surprisingly humble, sensitive and deeply invested in his work and determined to honour the Dior name while pushing forward into the future. Old techniques, including the time-consuming and expensive method of "imprimé chaîne", where each thread of a fabric is printed before being woven, are revealed to be almost impossible to achieve – and yet Simons is determined to experiment.

Throughout Raf Simons's relatively short time at Dior, his theme of modernizing original designs continued to

great critical acclaim, and the announcement that he would
be departing as creative director after barely three years
was surprising. Simons had admitted to frustration at how
fast he had to produce collections – six a year, including the
two gruelling haute couture shows – and lack of time to be
as creative as he would like to be. There was speculation
that the Dior brand, with its million-dollar celebrity
cosmetics and fragrance contracts and focus on commercial
success, made Simons feel alienated from his design ethos.
Nevertheless, despite attempts to persuade him to stay,
Simons's departure was amicable and he left Dior firmly
placed at the forefront of contemporary fashion.

MARIA GRAZIA CHIURI 2016–PRESENT

In July 2016, for the first time, Dior appointed a female
creative director, Italian Maria Grazia Chiuri, who
had previously worked for Fendi and Valentino. The
appointment was a natural one for a fashion house steeped
in femininity. From the beginning, the Dior look was all
about womanliness, accentuating female curves and creating
romantic silhouettes. Dior himself had many formative
female influences in his life and Chiuri similarly grew
up surrounded and inspired by strong women: her five
sisters, grandmother and, most importantly, her mother, a
seamstress, who gave her daughter an early love of fashion
and appreciation of the craft of creating clothes.

As a woman, Chiuri provides a particular angle on
fashion design. She is a working mother and self-proclaimed
feminist who appreciates that clothes need to answer many
needs – practical, aesthetic and even political. Before her
first show, she stated: "I strive to be attentive and to be
open to the world and to create fashion that resembles the
women of today." In an interview with American *Vogue*, in
speaking about women's changing attitudes to fashion in the
1960s, she stressed the importance of how Marc Bohan's
designs responded to his client's needs by making dresses
shorter and simpler, explaining: "It was not the designer who
changed the line, but the woman changed, and the designer
understood that the woman was different".

Chiuri's first collection for Dior was ready-to-wear rather
than haute couture. In it, she reflected the reality of fashion
for all women, not just an elite few. As a result, a wide variety
of styles were shown, including sportswear, streetwear,
evening wear and casual wear. This melting pot of design
included radical pairings such as an intricately beaded skirt

worn with a T-shirt bearing the slogan "We Should All Be Feminists", taken from the title of Chimamanda Ngozi Adichie's 2014 essay. Similarly, Chiuri put the title of Linda Nochlin's 1971 essay "Why Have There Been No Great Women Artists?" on another T-shirt.

Like all new designers to Dior, Chiuri researched the label's archives. But rather than just giving her take on the New Look, she took inspiration from all her predecessors –

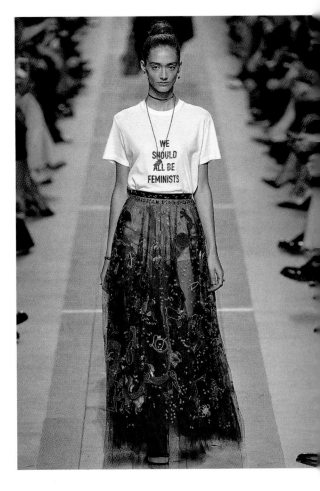

RIGHT As a steadfast feminist, Chiuri sent models down the catwalk for her first ready-to-wear collection in T-shirts emblazoned with the slogan "We Should All Be Feminists", the title of the groundbreaking 2014 essay by novelist Chimamanda Ngozi Adichie.

OPPOSITE Chiuri mixed up the transitions of Dior, putting romantic dresses with branded street-style accessories, as worn here by actress Jennifer Lawrence.

reinterpreting their reinterpretations, so to speak. She has variously referenced Yves Saint Laurent, John Galliano and Raf Simons, as well as Hedi Slimane, who headed up Dior Homme from 2012 to 2016. Chiuri likes to play with traditional masculine and feminine roles with a degree of ambiguity and androgyny in many of her designs. Among

all this modernism, however, she still finds influence in historical fashions, which are always an integral part of the Dior brand.

For Chiuri, focusing on wearability is essential to a modern Dior collection; the needs of the client are paramount, with modern tailoring a key element in her designs. But the romanticism that is at the heart of the Dior label is not lost, and she continues to create beautiful evening wear with all the trademark florals and embroidery that embody the Dior fantasy. Her 2019 foray into costume design, for the ballet *Nuit Blanche* at the Teatro Dell'Opera in Rome, is a case in point. For that production, she created ethereal dresses featuring tulle skirts juxtaposed with sportswear-inspired tops printed with Dior's haute couture flowers. Chiuri has reinvented Dior, taking the label from feminine to feminist. The woman who wears the clothes has the power – the designer is simply her translator.

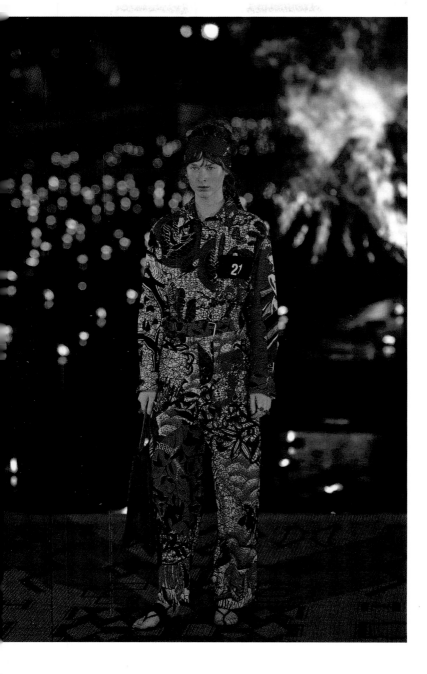

Accessories

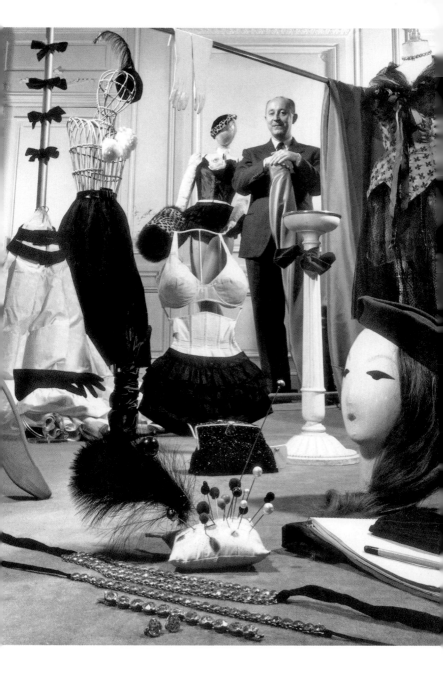

DIOR
FROM HEAD
TO TOE

Christian's Dior's New Look was more than just a revolutionary silhouette – it was a whole ensemble where the hat, shoes, gloves, bag and silk stockings were as important to the look as the dress or suit.

His iconic "Bar" jacket and flared skirt would not have looked the same without the domed straw hat with its instantly recognizable straw brim or the elegant, slim-heeled shoes. The designer regularly examined samples of accessories to pick the perfect ones to complement his outfits.

These accessories were originally made by carefully selected companies to which Dior licensed his name, starting in 1948 with his first deal for the manufacture of hosiery. In an unusual decision for the time, Dior took a percentage of sales rather than simply selling a licence to manufacture under his name. It was a profitable move, and this soon became the norm in the fashion industry. Over the years, the Dior name has been licensed to a wide range of products,

OPPOSITE Christian Dior stands in his showroom in 1955 with samples of design accessories for women, including hats, hat pins, gloves, muffs, lingerie, hosiery, evening bags and jewellery.

including hosiery, corsets, lingerie and furs, with a ready-to-wear fur line launched in 1973 and jewellery, including Dior's first watch, "Black Moon", in 1975.

Initially, these licences were given to well-established companies and designers. This included shoemaker Roger Vivier, who created a line of elegant shoes for Dior in 1953, and glovemaker Dents, who were appointed when Dior opened his London store in 1954. But over the next few decades, the Dior brand chased profit over reputation, overstretched itself and subsequently diluted the image of the couture house. By the 1980s, Dior had licensing agreements with around 200 companies. In an effort to restore the label to its former exclusivity, many of these agreements were allowed to lapse or were bought back. Later collaborations with accessories designers with excellent reputations of their own – such as milliner Stephen Jones, who created fabulous hats for John Galliano's haute couture fashion shows – have also contributed to the success of the Dior brand.

RIGHT Shoes were intricately designed by skilful makers to complement Dior's gowns. This evening shoe by Roger Vivier for Dior has a beautifully sculpted feathered butterfly detail.

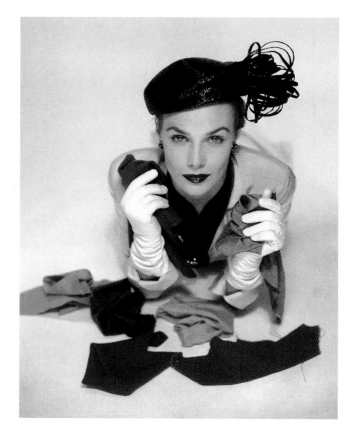

Bags have arguably become the most important of all Dior accessories, especially in recent years. Under Dior's original tenure, bags, like his clothes, had to be crafted from the finest materials and were painstakingly handmade to fit the sculpted, elegant Dior silhouette for both day and evening wear. In 1954, the designer advised: "You can wear the same suit from morning to dinner but to be really perfectly dressed, you cannot keep the same bag. For morning, it must very simple and for the evening, it must be smaller and, if you wish, a little fancier."

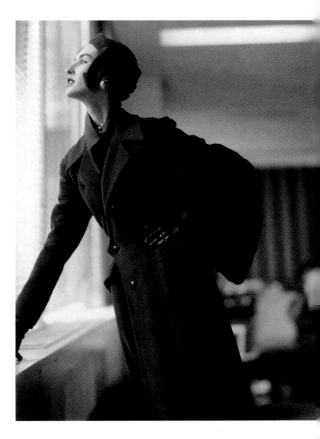

RIGHT This 1952
green velour town
coat with matching
hat, scarf and
muff are typical of
the coordinating
accessories that were
key to the Dior look.

Successive creative heads at Dior have all recognized the importance of providing a complete look for their clientele. With the launch of the Miss Dior ready-to-wear line under Marc Bohan in 1967, accessories became an even more important revenue stream. From there, the explosion in the cachet of the designer labels in the 1980s and 1990s led to the arrival of the so-called "It bag".

In 1995, French President Jacques Chirac's wife Bernadette presented Princess Diana with an elegant, black

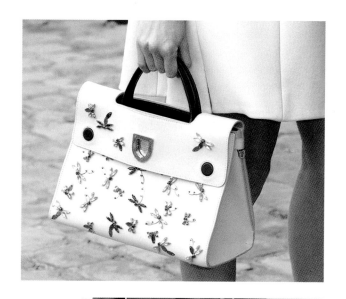

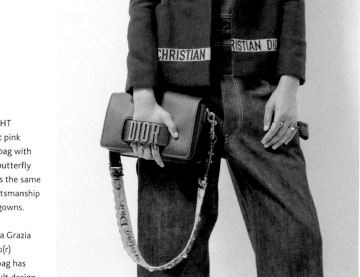

ABOVE RIGHT
This elegant pink
"Diorever" bag with
sequinned butterfly
detail shows the same
level of craftsmanship
as couture gowns.

RIGHT Maria Grazia
Chiuri's "Dio(r)
evolution" bag has
become a cult design.

padded square bag by Dior, then unofficially called the "Chouchou". Diana used the bag so much that it became associated with the much-photographed princess and it was renamed "Princesse" before launching on a larger scale as the "Lady Dior". The association with the most fashionable woman in the world led to Dior selling 200,000 bags over the next two years. Subsequent bags launched by Dior, including John Galliano's 1999 "Saddle" bag – beloved of Carrie Bradshaw in *Sex and the City* – and, more recently, Maria Grazia Chiuri's "Dio(r)evolution" bag for a new millennial Dior woman, have become almost as iconic in status.

RIGHT The Dior label has moved a long way from its beginnings in society elegance – today's brand is just as much a fashionable street-style statement as a timeless go-to.

ABOVE TV shows like *Sex and the City* went a long way to popularizing the cult of the Dior handbag.

ABOVE In 1995, French President Jacques Chirac's wife, Bernadette, presented Princess Diana with an elegant black padded square Dior bag that she used so much that it was renamed the "Lady Dior" in her honour.

Fragrance & Beauty

FINISHING TOUCHES

"Perfume is the indispensable complement to the personality of a woman, the finishing touch on a dress."
– Christian Dior

Christian Dior's love of flowers and the garden is legendary: his mother spent hours accompanied by her young son as she cultivated the garden at their first home by the sea in Granville. The houses he lived in as an adult all had wonderful gardens where he liked to sit and sketch new designs. This was especially true of his favourite home, La Colle Noir, where he grew flowers for his fragrances in the fields. Fresh flowers were abundant in the salon of his haute couture house and his designs are full of floral prints and embellishments. The scent of flowers was as seductive to the designer as their appearance, which is why perfume has been a part of the House of Dior right from its inception.

The designer founded his Christian Dior Parfums line with his childhood friend Serge Heftler-Louiche, but it was his favourite sister, Catherine, who inspired his iconic first scent. The story goes that Dior and his muse Mitzah Bricard

OPPOSITE Dior was as passionate about his fragrances as his haute couture, calling it "the finishing touch" to an outfit.

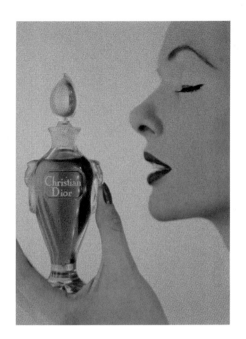

RIGHT Christian Dior's first fragrance *Miss Dior* was launched in 1947 and became an instant classic. This image from 1954 shows the Baccarat crystal bottle in which the scent was presented.

were playing with ideas for names for his debut fragrance, to be launched alongside his first haute couture collection, when his sister Catherine walked into the room. Mitzah exclaimed, "Look, there's Miss Dior!"; the English "Miss" rather than the French "Mademoiselle" spoke to the Anglophile in Dior, and he immediately proclaimed that this would be the name of his first perfume.

Miss Dior was created by Jean Carles and Paul Vacher with top notes of gardenia, galbanum, clary sage and bergamot and middle notes of carnation, iris, lily of the valley, jasmine, neroli, rose and narcissus – all the flowers that flourished in Dior's childhood beloved garden in Granville; his intention was to "create a fragrance that is like love". His sister Catherine, inspiration both in name and temperament for *Miss Dior* and to whom he was exceptionally

close his whole life, was fittingly involved in the growing and providing of flowers for Dior's fragrances. The scent was an instant classic and clients of Dior began to recognize that the house perfumes were as essential to their outfit as the shoes and bags that complemented it.

Christian Dior went on to launch *Diorama* in 1949, *Eau Fraiche* in 1953 and *Diorissimo* in 1956 before his death in 1957, but under subsequent designers, many more iconic scents have been launched. These include *Diorling* (1963), *Dioressence* (1969), *Diorella* (1972), *Poison* (1985), *Dune* (1991), *Dolce Vita* (1995), *J'Adore* (1999) and *Joy de Dior* (2018) for women. In 1966, the house launched its first eau de toilette for men, *Eau Sauvage*. All the scents, whether fresh or more heavily perfumed, share a link to the beloved flowers of Dior's childhood. Dior's current "nose" is a fellow Frenchman, François Demachy. Just like Christian Dior, smell transports him immediately to his own youth – in this instance, the lavender he associates with his grandmother's

RIGHT Dior expanded its fragrance ranges into other beauty products, including talcum powder and bath oil, as early as the 1960s.

ABOVE LEFT In 1966, Dior launched its first eau de toilette for men, *Eau Sauvage*. Early publicity materials claimed to make the Dior man "virile, discreet and fresh."

ABOVE RIGHT The iconic *Miss Dior* relaunched in 2017, 70 years after the original. The new fragrance, created by in-house perfumer François Demachy, has the same floral base but is subtly different, using techniques invented since the 1950s to capture a fresh mood for the modern Dior woman.

clean linens. In a 2017 interview with *The New York Times* after his creation of *J'Adore L'Or*, he explained how the creation of new perfumes still stays true to the passions of Christian Dior: "Mr Dior loved flowers like lily of the valley, so I have to keep that."

Cosmetics are also an intrinsic part of the Dior look, essential to the groomed elegance Dior sought in his designs. In 1953, then as part of Dior Parfums, a box set of eight shades of lipstick launched what would become a multimillion-euro cosmetics empire. In 1967, Serge Lutens was appointed as creative and image director of Dior cosmetics and in 1969, the first complete makeup line "L'Explosion de Couleurs" was launched. Since then, cosmetics and fragrance have become a huge revenue stream for the company, with high-profile celebrities and actresses including Marion Cotillard, Charlize Theron, Natalie Portman and Jennifer Lawrence signing lucrative deals as the face of the brand. Haute couture may be beyond the reach of most ordinary women, but fragrance and cosmetics are a way of buying a little of the Dior glamour at a fraction of the price.

RIGHT This 1972 shot shows a model with a face fully made up with the cosmetics line created in 1967 by Serge Lutens, creative and image director for Dior makeup.

BELOW Fragrance and cosmetics form a large part of Dior's revenue, promoted by multimillion-dollar advertising contracts with actresses like Natalie Portman.

INDEX

CREDITS

The publishers would like to thank the following sources for their kind permission to reproduce the pictures in this book.

Alamy: DPA Picture Alliance 73; /Everett Collection 15, 72; /Keystone Press 87b

Getty Images: AFP: 58, 95, 137; /AP 63, 67r; /Apic 12, 154l; /Archivio Cameraphoto Epoche 54; /ARNAL/PICOT/Gamma-Rapho 110, 111; /Authenticated News 92; /David Bailey/Conde Nast 155t; /Cecil Beaton/Condé Nast 84; /Serge Benhamou/Gamma-Rapho 10; /Bettmann 57, 81, 97, 102r; /Reg Birkett/Keystone 87t, 94; /Jean-Pierre Bonnotte/Gamma-Rapho 103; /BOTTI/Gamma-Rapho 102l; /Erwin Blumenfeld/Condé Nast 143; /Walter Carone/Paris Match 34; /CBS Photo Archive 17; /Chaloner Woods 153; /Chevalier 53; /Chicago History Museum 39, 56; /John Chillingworth/Picture Post/Hulton Archive 64; /Henry Clarke/Condé Nast 49, 61; /Corbis via Getty Images 50, 100; /Jean-Claude Deutsch/Paris Match 117; /Kevork Djansezian 78r, 79; /Alfred Eisenstaedt/The LIFE Picture Collection 85; /Fox Photos 108; /Swan Gallet/WWD 133; /Jack Garofalo/Paris Match 96; /AFP/Francois Guillot 125, 131; /Horst P. Horst/Condé Nast 59, 144; /Housewife 152; /Hulton Archive 140; /Maurice Jarnoux/Paris Match 66; /Gerard Julien/AFP 112; /Kammerman/Gamma-Rapho 38, 62, 150; /Keystone-France/Gamma-Keystone 22, 23, 75, 76t, 98, 101l, 101r, 109, 142; /

Claudio Lavenia 146; /Guy Marineau/Condé Nast 118;/David McCabe/Conde Nast 104; /Frances McLaughlin-Gill 60; /Mondadori 67l; /Guy Marineau/Condé Nast 114; /Lorenzo Palizzolo 145b; /Richard Rutledge/Condé Nast 48; /Pascal Le Segretain 126, 127, 135; /Silver Screen Collection 77b; /Sunset Boulevard/Corbis 71; /Tim Graham Photo Library 89; /Laurent Van Der Stockt/Gamma-Rapho 113; /Pierre Suu 145t; /Pierre Vauthey/Sygma 105, 107l, 116; /Victor Virgille/Gamma-Rapho 134; /Roger Viollet 35, 37; /Kevin Winter 78l; /

Iconic Images: Norman Parkinson 36, 41, 106

Shutterstock: 119, 147r, 155b; /AP 74; /Miquel Benitez 122; /Jacques Brinon/AP 128; /Fairchild Archive/Penske Media 107r; /Granger 28, 32t, 32b, 44, 46, 52; /JALAL MorchidiI/EPA-EFE 136; /Francois Mori/AP 121; /Tim Rooke 147r; /Roger-Viollet 7

Smithsonian Libraries: 12

V&A Images: © Cecil Beaton/Victoria and Albert Museum, London 82-83

Every effort has been made to acknowledge correctly and contact the source and/or copyright holder of each picture and the publisher apologises for any unintentional errors or omissions, which will be corrected in future editions of this book.

RESOURCES

Fury, A, Sabatini, A. (2017). *Dior Catwalk*. London: Thames & Hudson

Cullen, O., Karol Burks, C. (2019) *Christian Dior*. London: V&A Publishing

Dior, C. (1957) *Dior by Dior: The Autobiography of Christian Dior*. London: Weidenfeld & Nicolson

Cawthorne, N. (1996). *The New Look: The Dior Revolution*. London: Hamlyn

Muller, F. (2017). *Christian Dior: Designer of Dreams*. London: Thames & Hudson

dior.com

businessoffashion.com

vogue.com

thecut.com

wwd.com

en.wikipedia.org

nytimes.com

guardian.com

fashionunfiltered.com